THE SCHOOL OF
LONDON

the resurgence of contemporary painting

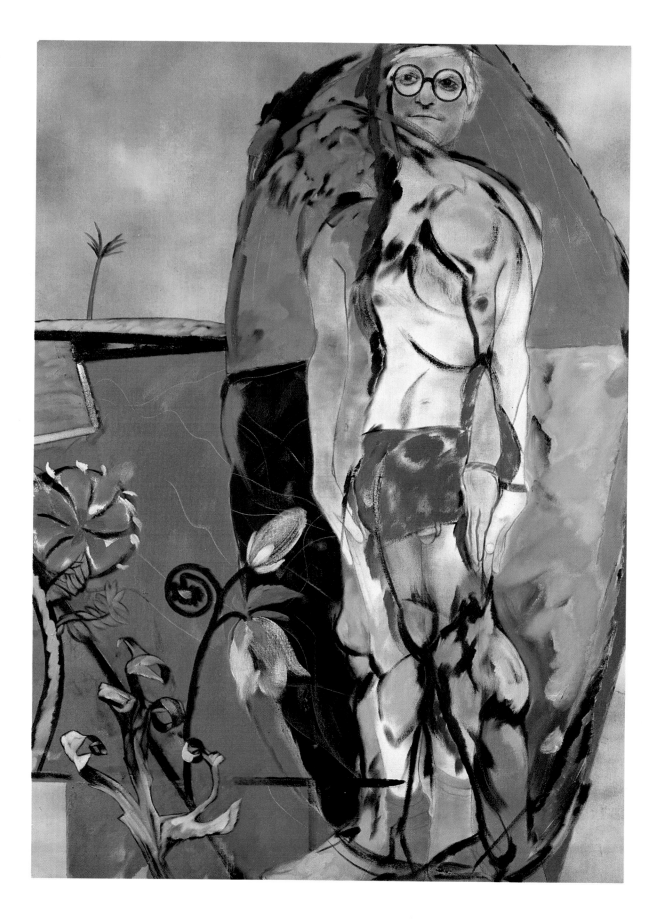

THE SCHOOL OF LONDON

the resurgence of contemporary painting

Alistair Hicks

PHAIDON · OXFORD

Phaidon Press Limited, Musterlin House,
Jordan Hill Road, Oxford OX2 8DP

First published 1989
© Phaidon Press Limited 1989
Text © 1989 Alistair Hicks

A CIP catalogue record for this book is
available from the British Library.

ISBN 0 7148 2511 5

Printed in Great Britain

Frontispiece R. B. Kitaj.
The Neo-Cubist. 1976–
87. Oil on canvas, 70 ×
52 in (177.8 × 132.1 cm).
Saatchi Collection,
London

ACKNOWLEDGEMENTS

This book would have been impossible without the co-
operation of the artists mentioned and I would like to
thank them for the time they have spent answering my
many questions and supplying me with vital informa-
tion. My editors at Phaidon, Penelope Marcus and
Mark Fletcher, have proved invaluable, and I would
also like to thank my wife and Lord Horder for read-
ing and re-reading the text. I thank Jennie Francis
for making it possible for me to write the book and
Kim Lockyer-Stevens for transcribing the tapes. I am
grateful to all who have lent photographs and must
mention a few individuals not credited in the photo-
graphic acknowledgements: Clive Adams, Judy
Adams, Kate Austen, Valerie Beston, Helen Bellany,
Anthony Brown, Kate Chipperfield, Robert Dal-
rymple, Julia Ernst, Pam Griffin, Christopher Hurst,
Catherine Lampert, Margaret Murray, Geoffrey
Parton, Dr Hans Albert Peters, Jayne Purdy, Louise
Spence, and Robin Vousden. I would like to acknow-
ledge Jacques Delacave's assistance. Finally, I thank
George Riches for commissioning the book.

Photographic acknowledgements

35, 36: courtesy Arts Council of Great Britain; 51:
courtesy Anne Berthoud Gallery, London; 2, 3, 22, 24,
25, 29: courtesy Anthony d'Offay Gallery, London;
41: courtesy Bernard Jacobson Gallery, London; 38:
courtesy Edward R. Broida Trust, Los Angeles; 44, 45,
46: courtesy John Bellany; 79, 80, 81: courtesy
Connaught Brown Gallery, London; 85: Harry
Diamond; 70, 71, 72: Fabian Carlsson Gallery, Lon-
don; 84: Dan. Farson; 56, 57, 59: Fischer Fine Art,
London; 31, 32: photograph: Christopher Hurst; 33:
Karsten Schubert Ltd, London; 7, 26, 27, 28: courtesy
of James Kirkman, London; 34: courtesy Knoedler
Kasmin, London; 4, 19, 20, 39: courtesy M. Knoedler
and Co. Inc. New York; 42: Kromeriz Statzanak,
Czechoslovakia; 40: Kunstmuseum, Düsseldorf; 1, 5,
8, 10, 11, 12, 13, 14, 15, 16, 17, 47, 48, 49, 50, 60, 61,
69: courtesy Marlborough Fine Art (London) Ltd; 9:
courtesy of Marlborough International Fine Art; 18:
National Galleries of Scotland; 30: National Portrait
Gallery, London; 58: courtesy of the Nicola Jacobs
Gallery; 38, 54, 55, 64, 65, 66, 67: courtesy the Nigel
Greenwood Gallery, London; 78: Pomeroy Purdy
Gallery, London; frontispiece, 21, 23, 82, 83: Saatchi
Collection, London; 6: Tate Gallery, London.

C O N T E N T S

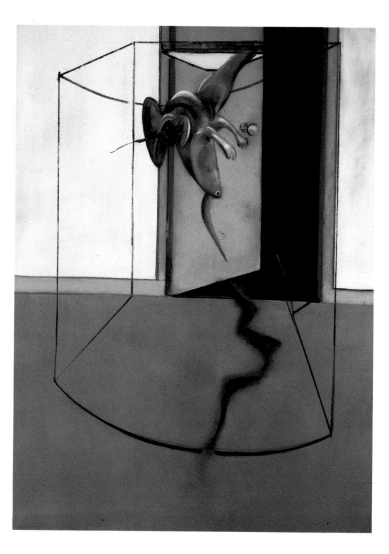

1 Francis Bacon
*Triptych Inspired by the
Oresteia of Aeschylus.*
1981. Oil on canvas,
each panel 78 × 58 in
(198 × 147.5 cm).
Private Collection

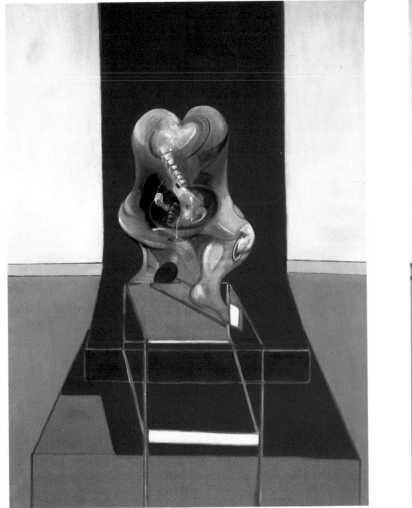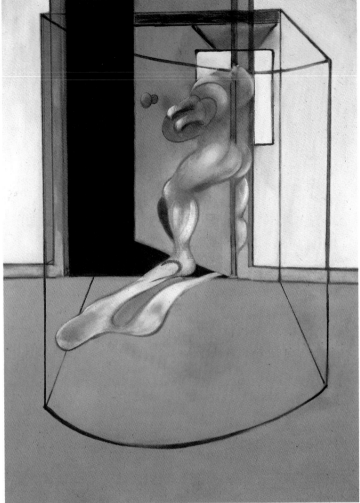

To Rebecca

P R E F A C E

British painting has never been so strong. This book is intended as a celebration of this fact and not as a comprehensive survey of British art. It is about the School of London. In line with Kitaj's original use of the term I have extended the School of London beyond the eight or so painters to whom the label has most frequently been attached. I have chosen twenty-four painters who are, or have been, centred round London and whose work most clearly explains the renaissance that has begun, and continues, to take place in Britain.

I have discussed the artists individually, revealing connections between them. and made great use of interviews with the artists to state their case as strongly as possible. As the first book on the School of London the priority is to stake its claims as a worthy and natural successor to the Abstract Expressionist School of New York.

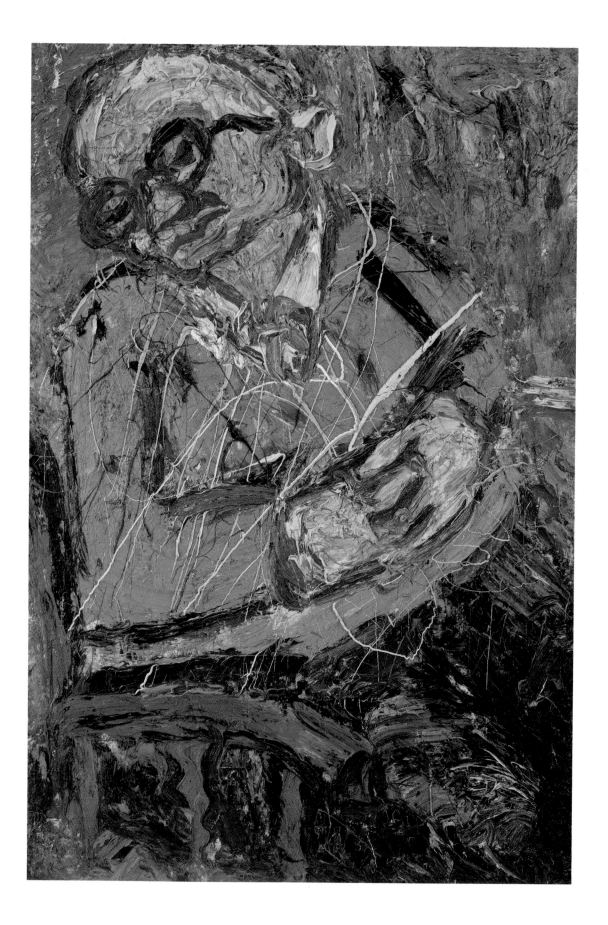

INTRODUCTION

Herd of Loners

The last thirty years have witnessed a renaissance in British art. There was a crisis in paint by the beginning of the sixties. As early as the forties artists as diverse as Fernand Léger and Victor Pasmore had declared easel painting dead. Abstract Expressionism became for many the swansong of painting instead of its life blood. Painting finally appeared to have come to a full stop. Yet it was precisely at this time that the School of London was born.

The movements that swept America and Europe in the sixties and seventies were Pop Art, Minimalism, and Conceptualism, all of which placed a low value on the process of painting. The American painter, Philip Guston's 'desertion' from abstraction in the late 1960s has been accepted as the great landmark heralding the 'figurative revival', yet a group of painters centred around London had challenged the legacy of Abstract Expressionism even earlier.

International claims were not made for the School of London till the middle of the 1970s. Its aims had been patently out of tune with the major world movements. By the end of the decade, however, Kiefer, Schnabel, and Chia and the other New Expressionists were stealing the thunder. Like crude voices in the wilderness they helped prepare the way for a serious public reassessment of the London painters and of the role of painting; they highlighted the fact that painting has been in a state of crisis for over thirty years.

The term 'School of London' was first coined at R. B. Kitaj's 1976 Hayward Gallery exhibition, *Human Clay*, when the works of thirty-five artists inspired by the human figure were shown. His introduction was entitled *School of London* and staked its claims in bold Salinger-style speech. 'There are artistic personalities in this small island more unique and strong and I think more numerous than anywhere in the world outside America's jolting artistic vigour,' wrote the Cleveland born, British trained artist. 'There are ten or more people in this town, or not far away, of world class, including my friends of abstract persuasion. In fact I think there is a substantial School of London . . . If some of the strange and fascinating personalities you may encounter here were given a fraction of the internationalist attention and encouragement reserved in this barren time for provincial and orthodox vanguardism, a School of London might be more real than the one I have construed in my head. A School of real London in England, in Europe . . . with potent art lessons for foreigners emerging from this odd old, put upon, very singular place.' His prophecy is coming true.

2 Leon Kossoff. *Portrait of Chaim*. 1987. Oil on board, 54½ × 36¾ in (138.5 × 93.4 cm). Anthony d'Offay Gallery, London

Kitaj didn't define the style of School of London; he left the term open to underline the point of his exhibition, which was to show the diverse strength of British art. There have been, however, several subsequent attempts to limit the phrase to a hard core of Bacon, Freud, Auerbach, Kossoff, Andrews, and Kitaj (Frontispiece). All of them but Kitaj were shown at the Beaux Arts Gallery, half of them frequented a Soho drinking club as recorded in Michael Andrews' *Colony Rooms* paintings (Plate 3), but it was never a cohesive group. There are important common factors, and these can be extended to others.

Francis Bacon (Plate 1), as the father of contemporary British painting, provides the key to understanding what the School of London is. His belief that it is still possible to concentrate human emotion on a canvas through the act of painting, has been the inspiration of all subsequent School of London painters. Kitaj's dispersal of the image might at first appear to oppose this concentration, but is simply another way of maximizing the information in the picture. There are three shared beliefs amongst all School of London painters: they show a whole hearted commitment to the process of painting; they demonstrate an ability to create their own pictorial language; and they express a desire to convey heightened emotions on canvas.

Perhaps the most important hallmark of the School of London painter is the last of these three: the desperate wish to pin down passing experience. 'Most of my paintings are the product of a crisis,' maintains Frank Auerbach (Plate 5). 'The look of my pictures is not conditioned by programme, but by the state of despair at not being able to finish them.' Lucian Freud reiterates, 'As far as I am concerned the paint is the person. I want it to work for me just as flesh does.'

I would claim there are three generations of the School of London. The first consists of Francis Bacon, Lucian Freud, Frank Auerbach, Howard Hodgkin, R. B. Kitaj, Leon Kossoff, Michael Andrews, and Victor Willing; the second of Gillian Ayres, John Walker, Maurice Cockrill, John Bellany, Andrzej Jackowski, Robert Mason, Terry Setch, Ken Kiff and Paula Rego; and the third: Christopher Le Brun, Thérèse Oulton, Hughie O'Donoghue, Arturo Di Stefano, Adam Lowe, William MacIlraith, and Celia Paul. The patient example of the older artists such as Kitaj has encouraged the two subsequent groups to find their own independent voices, to resist the need to be part of an art movement. 'One can no longer share a language like painters did in the eighteenth century,' declares Howard Hodgkin (Plate 4). 'To be an artist today one has to create one's own grammar first and then paint.'

The belief in the creation of an individual pictorial language has made it difficult to define the School of London's position as a group. Frank Auerbach maintains this lack of a definition has been an advantage. 'There is something quite bracing to be somewhere where painters are not categorized,' he says. Britain's indifference to her artists has bred a robust individuality. Nevertheless there is a common thrust.

The School of London owes more to Abstract Expressionism, Surrealism, Cubism, and Post-Impressionism than it does to earlier British painting. The infusion of new blood caused by the Nazi persecution and the Second World War ensured that the School would never be bogged down in the prevailing provincialism, which had held back even some of the greater British painters of the early part of the century. It is true that Lucian Freud has assimilated the best of the British tradition, but he has transformed it beyond recognition (Plate 7), as indeed have Auerbach and Kossoff (Plate 2) with the influence of Bomberg and Sickert.

3 Michael Andrews. *The Colony Room 1*. 1962. Oil on hardboard, 48 × 72 in (122 × 183 cm). Private Collection. Francis Bacon sitting far right — Lucian Freud standing in the centre facing out.

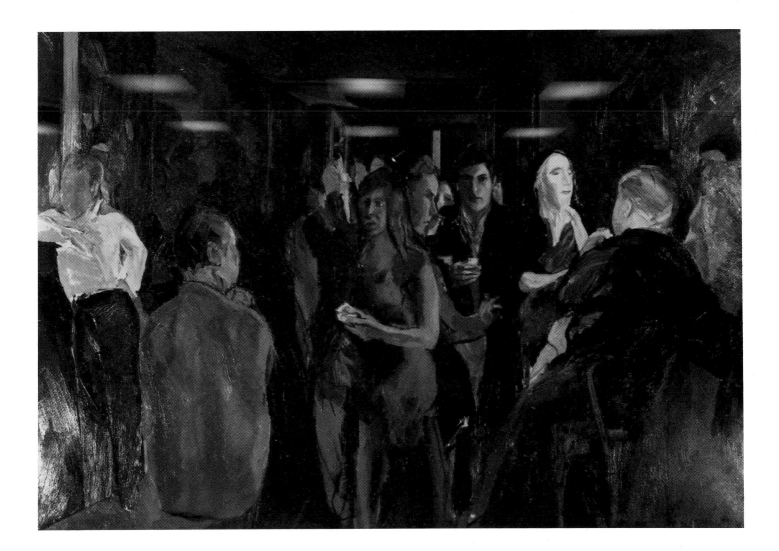

4 Howard Hodgkin. *Reading the Letter*. 1977–80. Oil on wood, 17¾ × 20 in (45 × 50.75 cm). Private Collection, New York

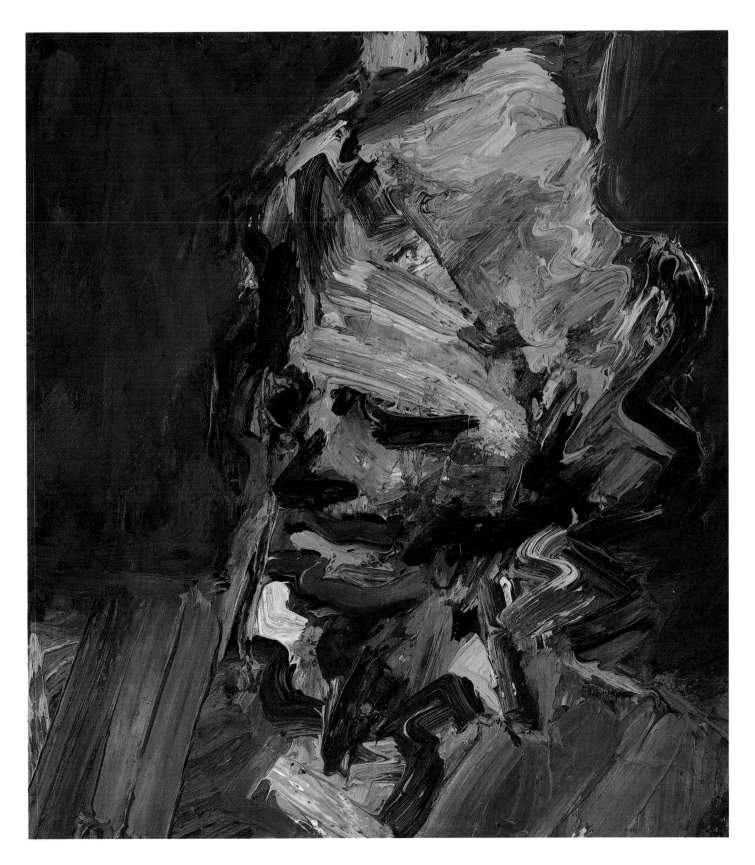

5 Frank Auerbach. *Head of Catherine Lampert*. 1986. Oil on canvas, 20¼ × 18½ in (51.4 × 47 cm). Private Collection

Bacon, Kitaj, and Hodgkin have virtually no connection with earlier twentieth-century British painting and Gillian Ayres who has trawled British painting for anything she can use, particularly the work of Roger Hilton, is the first to acknowledge that, 'It was the Americans who kept painting alive in the fifties.' Time and time again the artists in this book, particularly those of the second generation, refer to Jackson Pollock (Plate 6). It is difficult to imagine the pure expression of human energy through paint that manifests itself in British painting without the work of Abstract Expressionism.

That the British should have taken up the flag of contemporary painting from America is at first startling. They have shown a staggering indifference to contemporary art throughout this century. As early as 1915 Wyndham Lewis was lamenting, 'Almost alone among the countries of Europe she [England] has proved herself incapable of producing that small band of wealthy people who are open to ideas, ahead of the musical-comedy and academics of their age, and prepared to spend a few hundred pounds a year less on petrol or social pyrotechnics, and buy pictures or organize the success of new music or new plays.' Surprisingly the flowering of American painting was born out of similar conditions. True, Americans have been much more enthusiastic for painting this century, but before World War II there was a great bias towards Europe. Painting within America and England had been provincial for many years. Both benefited from an influx of painters from abroad.

London may have been in the shadow of New York for the first thirty years after the War, but the School of London painters escaped the American critic Clement Greenberg's Modernist umbrella. Not since Ruskin has a critic held such an authoritarian control over artists. It was Greenberg who dictated that painting should be reduced to the minimal surface, without any threat of illustration. Though he found many followers in Britain he never fully controlled the British art world. London, as both the actual and cultural capital, plays a more commanding central role within Britain than do America's or Germany's cultural capitals, New York and Berlin, but it does not have the same hot-house mentality. It is perhaps the second most important art centre in the world, but there is no essential intellectual meeting place. The auction houses, the galleries, and the art schools provide a network of information and gossip, but it is very rare for an art event to attract more than a few important rabbits from out of their warrens at any one time.

London is a sprawling metropolis. The connections between the many worlds it contains are haphazard. Its artists can, and frequently do, live hermetic lives. They are almost as likely to mix with Soho drunks, politicians or plumbers as they are with other artists. The attraction of London to several artists has been that they can get on with their work and be left alone. Kossoff, Auerbach, Kitaj, and even the once notoriously social Freud, are now what Kitaj himself called a 'herd of loners'. It's not surprising therefore that they have developed one of the great twentieth-century themes: the isolation of man. In their fragmented world a common pictorial language would be an artificial restraint. Some of these artists live outside the city – Gillian Ayres lives in Cornwall, Andrzej Jackowski works in Brighton, and Terry Setch's studio is in Cardiff – but all are reacting to their position in the environment. London itself is no more important to painters than it is to other Britons. It is merely at the centre.

The solitary position of the artist in British society has had some strange results. We have long been proud of being an island of eccentrics and have delighted in the idiosyn-

cratic visions of Blake, Fuseli, Dadd, Spencer, and Lowry. Quite understandably there has been a resistance to art movements in this country. Most have faded away here, derided for their pretensions or failing to achieve the attention they sought. If today's 'herd of loners' had been planned it could be described as the perfect British compromise. There is a steady flow of good exhibitions in London today and there is always a pool of new ideas, but the individual painter is still very much working on his own, making a direct response to the preoccupations of everyday life, rather than being over-con-

cerned about the views of an often inward looking artworld.

There are two main strands of the London School that develop out of Bacon, those artists who produce images out of the paint and those who, following on from the Cubists and Surrealists, look for new ways to pack their paintings with information. These poles are represented by the Castor and Pollux of British painting, Auerbach and Kitaj. Yet their disparate styles join together in the work of the following artists.

The division of the School of London into three groups is not simply a question of age.

6 Jackson Pollock. *Yellow Island.* 1952. Oil on canvas, 56½ × 73 in (143.5 × 185.4 cm). Tate Gallery, London

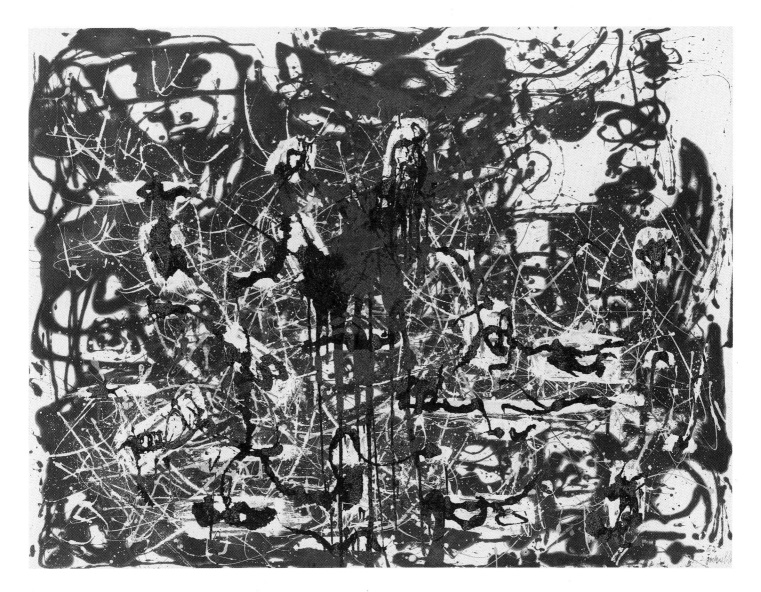

7 Lucian Freud. *Esther.* 1980. Oil on canvas, 19¼ × 15 in (48.9 × 38.3 cm). Private Collection

The span of the first generation of the School of London is twenty-three years. Some of those included in the second grouping are older than Kitaj, Hodgkin, and Auerbach, but their concerns are slightly different. Many of the second wave of artists have allegiances to places outside the capital, which partly explains their delayed impact on the School. This second group could not be identified for many years with the main body as they were shadowing them. They were walking beside them, exploring similar ideas, working towards a common goal, but still patently apart. Freud talks of making the paint flesh. Walker, Setch, and Cockrill — artists from the second group — assume that the paint will take on the character of their subjects. Images and energy come out from behind this curtain of flesh made of paint.

The youngest generation has a new standpoint. Unlike some of the older generation they are not threatened by the minimalist declaration that paintings can no longer be seen as windows and have pursued the way forward led by the great American isolationist, Jasper Johns and the Anglo-American, Kitaj. This generation attempt the impossible, trying to develop the flat surface into infinity whilst producing images of everyday life. They bind their specific images with a sweeping movement, a sash of paint. There is a desire to pursue the figurative tradition whilst stealing the best from abstraction.

Man's relationship to his environment recurs as the prevalent subject matter of all three generations of the School of London. The city itself has provided a rich vein of subjects and scenes for some, but most of the artists have not benefited so directly from the capital. More importantly myth, reverie, and even early Christian dogma have been revitalized to reveal how we live today. Bacon has exploited myth, most successfully. He claims that his world could never be as shocking as newspapers, television, or film, but by injecting the weight of man's memory into his images he denies this. His paintings are far more effective.

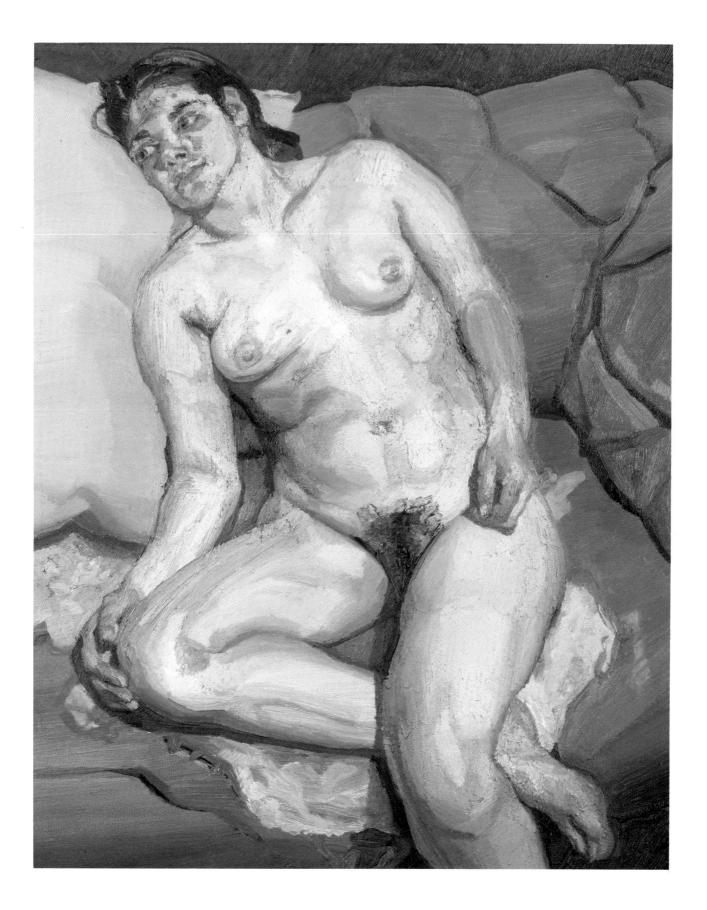

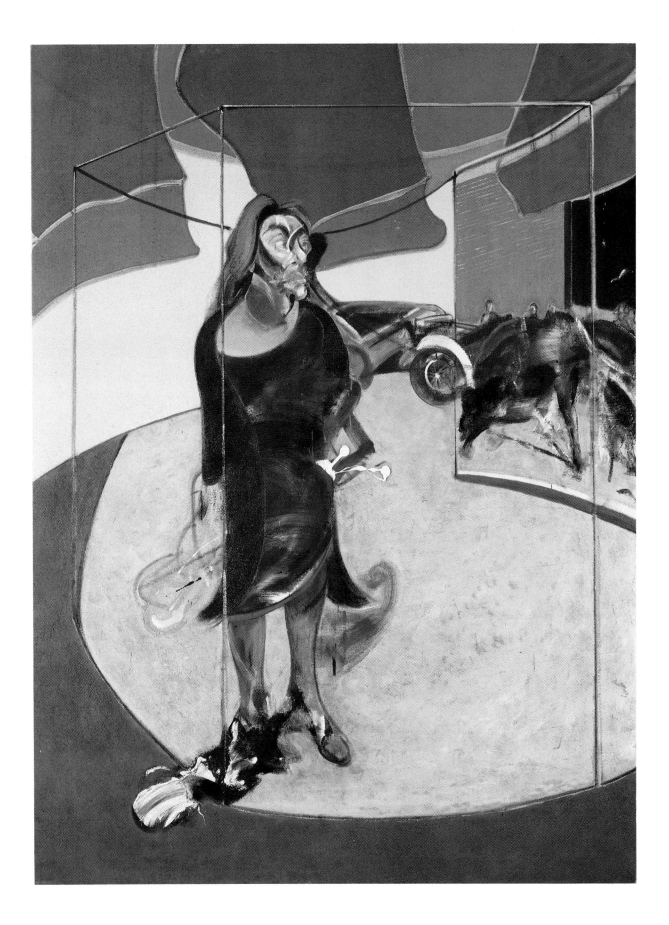

CHAPTER ONE
Crisis in Paint

Francis Bacon (born Dublin 1909) has invented a new language far removed from the insular British tradition of painting. From the beginning he proclaimed his international approach. *Three Studies for Figures at the Base of a Crucifixion* (Plate 10) left little doubt over his intention to be in the tradition of Grünewald, Goya, and Picasso when it shocked the public at the Lefevre in April 1945. Indeed it was the 1928 Picasso exhibition at the Paul Rosenberg Gallery in Paris that first prompted him to paint.

Bacon attacks the accepted vision of the world. He distils emotion onto canvas in the same way as the Greek tragedians made the chorus spill their cries into the open air. 'Great poetry,' he says, 'makes an assault on the nervous system.' He is accused of violence, extreme pessimism and perversion, but he defends himself eloquently. 'Look at the newspapers, television and films—who could compete with that?' he demands. 'Reality is cruel. I try to trap realism.'

The stage on which Bacon's undiluted emotions dance has a grand simplicity. Even Matisse could not have designed a simpler framework for the complicated dissection of a human being than Bacon's suspension bridge in *Triptych—Studies of the Human Body* (Plate 9). There is nothing else to look at except for the bodies balanced on the arched gym bar and the central figure whose bulging thighs are given the extra support of a truncated Masaccio throne. The unusual background of lilac fills most of the picture space. It further focuses attention on the solidity of the torso, sitting potently on its slab in sharp contrast to the flying limbs on the wings. The heavy sensuality is confused by the top of the central figure, who bursts above her bosoms. Is the umbrella adequate protection for these gaping wounds?

Though Bacon has made use of Greek drama and has formed a pictorial language of classic simplicity, he debunks the classical ideal of beauty. When he received a small unidentified book from Michel Leiris, he immediately ringed a passage written under Baudelaire's influence. 'We can call "beautiful" only that which suggests the existence of an ideal order—supra-terrestrial, harmonious and logical—and yet bears within itself, like the brand of an original sin, the drop of poison, the rogue element of incoherence, the grain of sand that will foul up the entire system.' There are many examples of 'this grain of sand' in Bacon's work. Paintings appear to be reaching a state of perfection, when suddenly there is splash of paint like a schoolboy's splat of ink. *Portrait of Isabel Rawsthorne Standing in a Street in Soho* (Plate 8) has several such marks. They

8 Francis Bacon. *Portrait of Isabel Rawsthorne Standing in a Street in Soho*. 1967. Oil on canvas, 78 × 58 in (198 × 147.5 cm). Staatliche Museen Preussischer Kulturbesitz, Nationalgalerie, Berlin

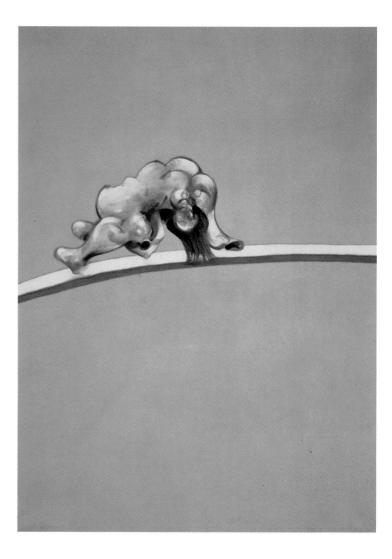

9 Francis Bacon.
*Triptych—Studies of the
Human Body*. 1970. Oil
on canvas, each panel
78 × 58 in (198 ×
147.5 cm). Marlborough
International Fine Art

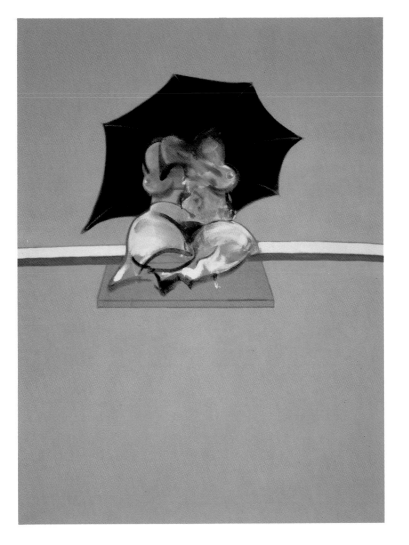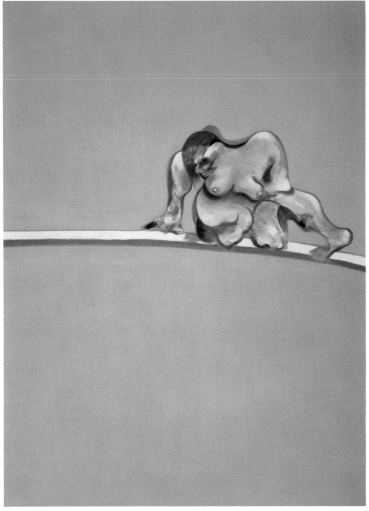

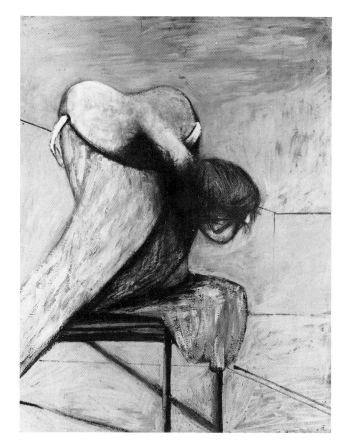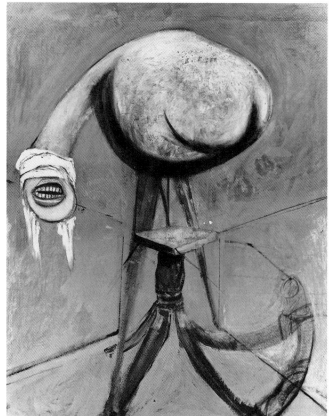

add reality. They make the viewer realize that this is the world in which we live, warts and all.

The Rawsthorne portrait possesses many of the qualities that make Bacon important. There is a tight framework. His fellow Soho *habitué* is both contained in a box and on an active open street in the arena of a city. The top of the picture is fragmented like a jigsaw puzzle. A speeding car is glimpsed, but reduced to a stationary backdrop. The 'action' is in the mind. The raging emotions of a spiked beast, the resolutely placed feet, and her bull face, form the triangular base of the picture. There is a bustle of activity, but the artist isn't interested in telling stories. 'I don't like stories,' he says. 'I am not a narrative painter. I want to convey reality without illustrating.'

Though many of his most successful paintings owe their origins to some of the greatest stories of all time, a detailed knowledge of Aeschylus, Homer, and Euripides is far from essential. He has merely borrowed legendary characters to unleash primeval fears, to arrest raw anxieties. The Soho painting does the same. Isabel Rawsthorne may stare diagonally out of the canvas, isolating herself from the rest of the activity in the painting, but her face could be a painting in its own right. It is a mask and yet lays her bare. She both performs in the ring and is in a world totally of her own.

Bacon is a Nietzschean in his dislike for unnecessary props. He thinks about death every morning. As the posthumous paintings of George Dyer show, even the death of his closest friend could not make him believe in an afterlife. They may show the horror of death but they totally accept it. He has to paint about life. He is a natural creator, as he confided to David Sylvester when questioned on the mess of his studio, 'I feel at home here in this chaos because chaos suggests images to me.' His subjects come flowing out of his

10 Francis Bacon. *Three Studies for Figures at the Base of a Crucifixion.* 1944. Oil and pastel on hardboard, each panel 37 × 29 in (94 × 74 cm). Tate Gallery, London

11 Frank Auerbach. *Catherine Lampert*. 1983. Oil on board. 22 × 16 in (55.9 × 40.6 cm). R. B. Kitaj

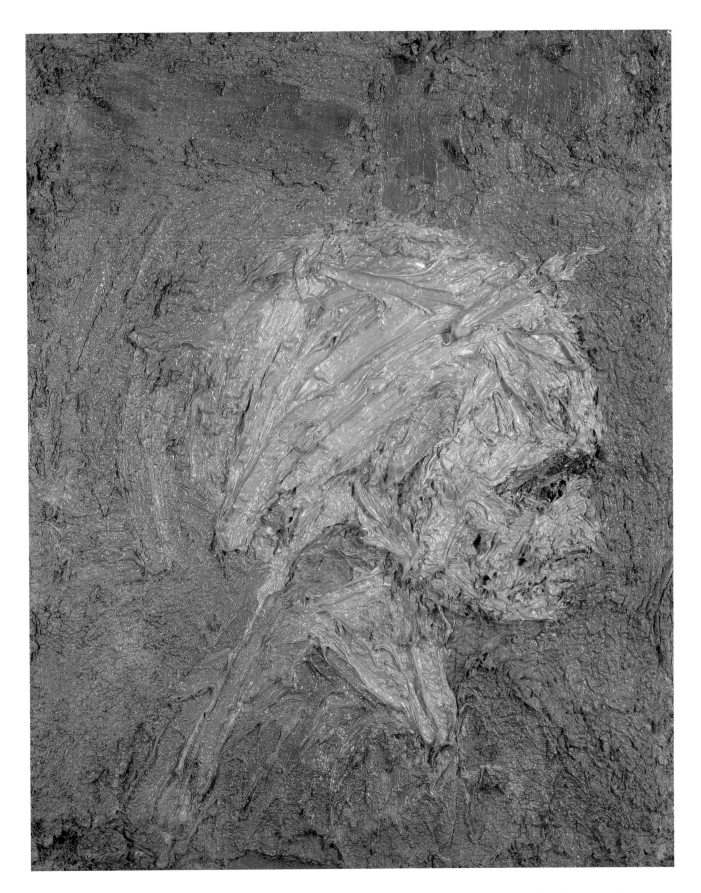

12 Frank Auerbach. *Head of E. O. W.* 1958. Oil on board. 20 × 16 in (50.8 × 40.6 cm). Mrs Rosemary Peto

unblinkered gaze from the rough life he leads. His pictorial grammar had to be locked firmly in place in order to portray this. In the first twenty years of his painting life abstraction was the law, yet he believes: 'Without a subject you automatically go back into decoration because you haven't got the subject which is always eating into you to bring it back—and the greatest art always returns you to the vulnerability of the human situation.'

Bacon's stand for his own art in the face of a frighteningly orthodox avant-garde was an inspiration to several younger painters. Indeed the seeds for many subsequent developments in British painting were sown by him. Commenting on his preference for painting portraits with no one else in the room he says, 'If I am on my own I can allow the paint to dictate to me.' **Frank Auerbach** (born Berlin 1931) elaborates this point. 'The paint itself seems to breed images,' he observes. 'I try to take the picture to the point where it seems to make itself. It doesn't have anything to do with thickness, but there is a give and take between the picture and oneself. One picks up figures from the paintings and one tries to impose one's desires on them.'

Catherine Lampert (Plate 11) by Auerbach can be read in many ways. It is a field of vigorous strokes from a richly laden brush. The eye cannot resist wandering off into areas of luxurious paint. Though the shape of a head is obvious enough, the face does not necessarily leap out at the viewer. The head and body are taken over by geometrical shapes. Features emerge in flashes and then disappear again. This keeps the eye working, looking into the paint and then retreating. The painting maintains constant interest, but most importantly every one of Auerbach's violent actions that leaves a sweeping passage of paint or merely a mark on the canvas contains the spirit of the sitter, or rather the interaction between the sitter and painter.

Auerbach only paints people he knows intimately. He says, 'painting someone close to me seems so urgent, necessary. It is also more dangerous. There is a possibility of quarrelling.' His frenetic energy is heightened to a pitch of frustration, 'more like an hysteria' at not being able to finish the painting. 'Unless one was conscious of the fact that life was short and one was going to die, there would be no sense in making this sort of effort.' He recalls: 'I began to realize what I wanted to do as a painter . . . after about five years of being a student [at St Martin's and then the Royal College]. I was living with someone, who has the initials E.O.W. (Plate 12). She was the most important person in my life at the time . . . The intensity of life with somebody and the sense of its passing has its own pathos and poignancy. There was a sense of futility about it all disappearing into the void and I just wanted to pin something down that would defy time, so it wouldn't all just go off into thin air. This act of portraiture, pinning down something before it disappears seems to be the point of painting. Our lives run through our fingers like sand, we rarely have the sense of being able to control them, yet a painting by a good painter, say by Manet, Hogarth, or Velasquez, represents a moment of grasp and control of man over his experience. That seems to make life more bearable.'

For many years Auerbach (and Kossoff) used extremely thick paint and dark colours. Asked to confirm the legend that sheer economy forced him to reduce his palette in the fifties, he said, 'Yes and Rembrandt a bit as well.' Certainly there is a strong echo of the Dutch master in these works. Helen Lessore wrote in *A Partial Testament*, 'I remember the extraordinary effect of Auerbach's early paintings, all in yellow ochre,

grooved, engraved, as if in wet gravelly sand: as if one had fallen asleep after long contemplation of some Rembrandt with a glimpse of mysterious parkland in the golden-brown distance, and then in a dream found oneself actually walking in the landscape.' In the early sixties after several exhibitions at Lessore's Beaux Arts Gallery, inclusion in Sylvester's *Critic's Choice* at the Tooth Galleries and shows abroad, Auerbach persisted with only a few colours. Indeed he produced a series in black and white, among which there are many of E.O.W.

Auerbach believes all great modern artists have been reductionists. 'Obviously it is more exciting,' he says, 'to express fifty sensations with one mark than the other way round. One wants the richest possible materials and richest possible sensibility of subject expressed in the most economical way.' He is often criticized for limiting his subject matter. As well as his very few regular sitters like his wife Julia, J.Y.M., and Catherine Lampert, one of Britain's best exhibition organisers and wife of the artist Robert Mason, he paints his beloved London. 'I am not very confident at arranging my life and so I have got into certain habits,' he confesses. 'When I go out into the London streets I always find it interesting—chaos and atmosphere.' He invariably chooses to paint two sites, Primrose Hill and the approach to his studios. 'The subject becomes richer the longer I go on with it,' he explains, 'unused possibilities present themselves.'

For every landscape Auerbach paints he makes about two hundred sketches. I visited him when he was painting *Tree on Primrose Hill* (Plate 13). 'I've had a thousand other sensations in the course of painting than the one I finally pin down,' he said. Whilst painting he claims to be thinking primarily of geometry. 'I don't regard the painting as finished till it is locked geometrically for me in a way I hadn't foreseen.' The body of

Catherine Lampert is surprisingly locked in this way, but his drawings are perhaps the best demonstration of the way he pins down his sensations. Sometimes he does this with a few bold strokes as in *Head of Sue Aron*, but usually more frenzied marks and crossings are in evidence. The key to his work comes from this struggle between spontaneity and a relentless belief in form. He scrapes away his efforts until he achieves the desired feel of immediacy. The finished product is always the result of one session. However long he may have worked on that very canvas there is minimal paint left from previous sessions. *Study for Tree on Primrose Hill 11* (Plate 14) demonstrates this battle between the fluidity of paint and the rigid skeletal structure.

The production of images out of the paint came with the welding of concept and technique. In Auerbach's work the two are indistinguishable, but he himself plays it down. 'I didn't set out to do anything particular with the paint. The business of medium, the language people use, may not be the essential thing. It is just barely possible that if I'd gone to a different art school, been born three years later and met different people, the actual idiom might have been different, though there are certain aspects of personality that wouldn't have changed.'

Much has been made of Bomberg's impact on Auerbach when he attended night classes at Hampstead Borough Polytechnic. Catherine Lampert records Auerbach's instant reaction to his tutor in her 1978 interviews. 'I knew . . . that one's teachers were going to be silly fools and that one was going to rebel against them. Then I was seventeen and I went to Bomberg's class where he said to me, "Oh so you think I'm a silly old idiot don't you?", or something like that, and I said in my seventeen-year-old arrogance, "Yes I do." He was delighted.' There were two sides

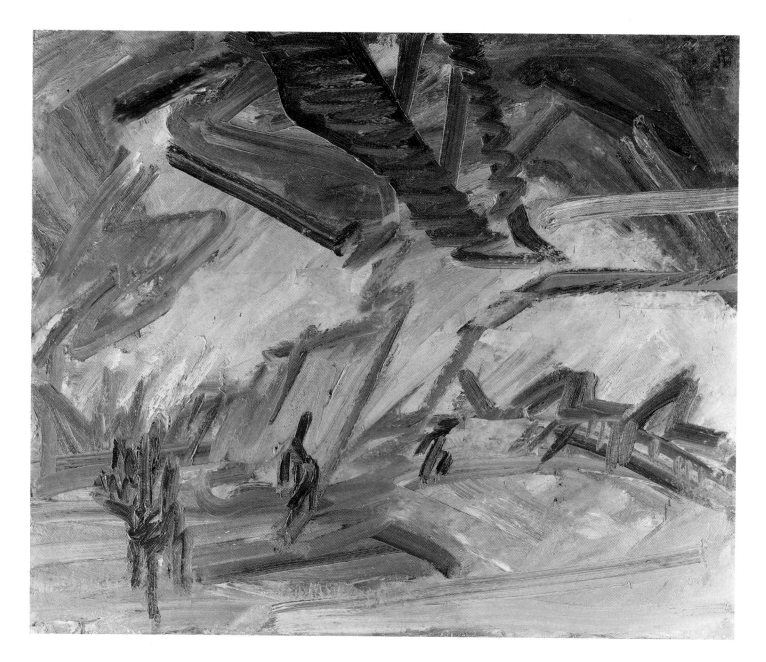

13 Frank Auerbach. *Tree on Primrose Hill*. 1985–6. Oil on canvas. 45 × 55 in (114.3 × 139.7 cm). Private Collection. USA

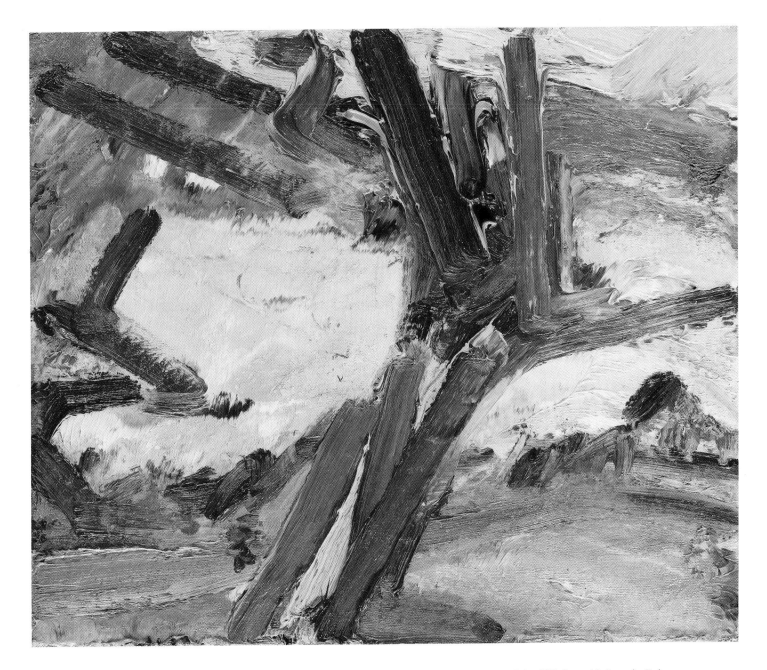

14 Frank Auerbach. *Study for Tree on Primrose Hill 11*. 1986. Oil on canvas, 14 × 17 in (35.3 × 43.2 cm). Private Collection

of Bomberg according to his pupil, 'his theorizing and his extraordinary sensibility.' It was the latter that influenced him far stronger than technique, palette, or theory. 'Bomberg's outlook went beyond fulfilling reasonable expectations of an art school,' he states. 'When he taught he spoke the same language to his students as he might address to himself. The demands he made of us were as stringent as the demands he made on himself when working.'

Attempts to link Auerbach with an earlier British tradition are overplayed. There are connections with Bomberg, Sickert, and Gainsborough. There are even similarities to Matthew Smith, Mark Gertler, and Jack Butler Yeats, but there are more differences. To stress Auerbach's British inheritance is as facile as claiming that Kossoff and he are the ultimate Modernists because of their concern with surface. He does, however, repeat one piece of Sickert's advice, 'There is only one thing for painters to do—keep their heads down and work'. He never needed urging. He works as many hours of the day as possible and often sleeps in his studio. He finds painting 'endlessly engaging'.

Auerbach admits that he is challenged by his contemporaries, particularly Lucian Freud and Leon Kossoff. 'It is absolutely true,' he says, 'in one's own time and in one's own place the feats of art are most effective and most poignant and most stimulating . . .—one feels a worm if somebody else has done something very ambitious and very risky and which requires enormous tenacity and austerity and energy to carry it through—one feels a worm if one doesn't try to do something on the same level, and that is good for one.' He also gives credit to Bacon, 'Bacon's grandeur of ambition has pulled up British painting. I haven't Bacon's physical energy, nearly everything he has done has been National Gallery size. Also he has invented a lot of things out of photography,

memory, reading, and other pictures, whilst I only work from drawings and people. Therefore although I might sometimes flatter myself that I may be marginally more varied formally, I am certainly infinitely less visionary.'

Bacon recalls that his parents thought him eccentric to want to be an artist. His father was an Irish racing trainer who never had much in common with his son. Auerbach had no such problems. Born in 1931 in Germany he had to flee to Britain. 'I didn't see my parents after I was seven,' he recalls. 'This might be an important influence. I had various sorts of education, a curious boarding school, austere and demanding, a lively community and intellectually snobbish. It was run by excellent teachers, foreigners, and conscientious objectors.' It was a far cry from the usual British visual education. 'One got the impression that activities such as painting were valuable.'

Auerbach is proof for Kitaj's forthcoming *First Diasporist Manifesto*. In this **R. B. Kitaj** (born Cleveland, Ohio 1932) maintains that most of the major movements of the century, for instance the three schools of Paris, the School of New York, and School of London, have depended heavily on outside blood and particularly migrant Jews. Kitaj was born in the United States, became an American GI after a period in the merchant navy and took advantage of training at the Ruskin in Oxford and then the Royal College of Art in London. Despite several attempts to re-settle at least for part of the year back in the United States, he finds the London environment best suited for his temperament. As the *Human Clay* exhibition of 1976 proved he has been for many years a guiding light in British painting.

Kitaj's painting is radically different from Auerbach's, Freud's, and Kossoff's. Whereas the other three attempt to transform paint into flesh and usually rely on one strong

image, Kitaj disperses the image. He is also the only one to believe that talking and writing about one's work is of vital importance. He is a scholar in the tradition of 'the book people', who have been brought up for thousands of years to discuss the scriptures, to be able to debate every line of the Torah, and read interpretations out of the written word. Kitaj has applied a similar technique of exegesis to pictures. Judaism banned image making; before this century there were very few important Jewish painters. Orthodox Jews are neither allowed to name God nor make an image of him, because by doing so they are diminishing God, controlling him, creating him in their own image. This might be a reason why so many of the twentieth-century Jewish artists have veered towards abstraction. It also provides a suitable background to Kitaj's fragmented compositions. His works deny the possibility of ultimate revelation, of one simple solution to a problem. Instead they build up a picture of countless glimpses.

Kitaj was at first sceptical about linking his fragmentary approach to Judaism. 'As to a connection between image dispersal and anti-image in Jewish tradition—I might have said no,' he wrote to me. 'I don't feel any connection because I had no religious training whatsoever, but upon reflection, many of the precursors who fed my earliest Modernist attempts were strange Jews with identity crises, which often results in fragmented life-work. The father of modern art history, Aby Warburg and disciples like Saxl, Wind, and Panofsky . . . Benjamin and above all Kafka at his most disjointed, always turned me on—more recently Paul Celan. There may be truly something in what you suggest though all these people might deny it! I also deconstructed images (and still often do) as a grandchild of Surrealism (as did Picasso *et al.*).' Whatever, there is an uncanny relationship between his obsession with the Diaspora and the dispersal of the image in his art. His breaking up of the picture mirrors the great dispersal of the Jews.

Kitaj's interest in Jews and Jewishness has manifested itself most obviously during the last five years in his series of paintings and drawings on the Holocaust. He invented a sign for this Jewish passion. 'The appearance of the chimney in some of my pictures,' he wrote, 'is my own very primitive attempt at an equivalent symbol, like the cross, both after all having contained the human remains in death.' *Passion (1940–45) Writing* (Plate 17) is one of the most poignant, with the young representative of 'the book people' contained neatly within his chimney coffin. Absorbed in his writing his quill provides the first curl of smoke.

From the very start Kitaj's work has been concerned with a fragmentary life. *The Erasmus Variations*, painted in his first year at the Ruskin and called after some doodles by the great humanist, gives the most blatant display of the many sides of human nature. By the mid-seventies when he painted one of his great masterpieces, *The Autumn of Central Paris (after Walter Benjamin)* (Plate 16) this packing of contrasting information on the canvas had become more sophisticated. Benjamin is crucial in this: 'His personality began to speak to the painter in me,' he wrote, 'the adventure of his addiction to fragment-life, the allusive and incomplete nature of his work (Gestapo at his heels) had slowly formed up into one of those heterodox legacies upon which I like to stake my own dubious art claims.' He depicts the café life of Paris, the endless discussions and meeting of apparently irreconcilable ideas in the very season that the Nazis marched in. The night-life, the entertainment, the bandstand, but above all the conversation is underlined by the current of the socialist struggle of the people portrayed by the

15 R. B. Kitaj. *Cecil Court, London WC2 (The Refugees)*. 1983–4. Oil on canvas, 72 × 72 in (182.9 × 182.9 cm). Tate Gallery, London

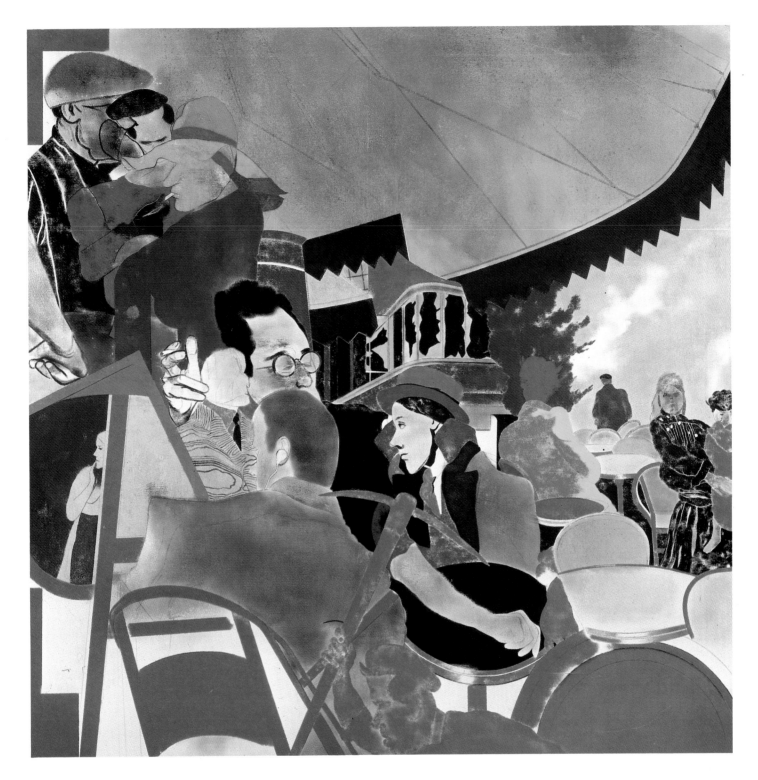

16 R. B. Kitaj. *The Autumn of Central Paris (after Walter Benjamin)*. 1972–3. Oil on canvas, 60 × 60 in (152.4 × 152.4 cm). Private Collection, New York

17 R. B. Kitaj. *Passion
(1940–5) Writing.* 1985.
Oil on canvas
(unfinished), 18 × 10½
in (45.7 × 26.7 cm).
Collection of the artist

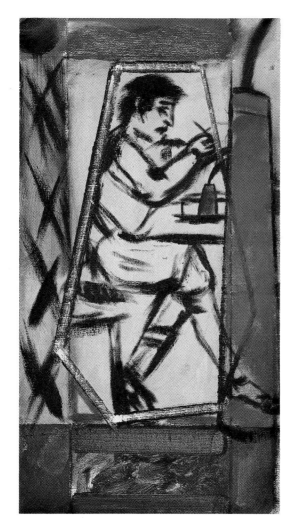

worker with the pick and the red that sweeps
up from the bottom of the picture. As he is
driven to his suicide, Benjamin is seen as a
container of countless, disconnected compo-
nents of civilisation. Kitaj's masterpieces
like *The Autumn of Central Paris, If Not, Not*
(Plate 18) and *Cecil Court, London WC2
(The Refugees)* (Plate 15) rely not only on
capturing those scattered moments, but also
on bringing them together into a shocking
compositional unity.

The Neo-Cubist (Frontispiece) is Kitaj's
most astute comment on the state of painting
today. It pokes gentle fun at artists' aspira-
tions to follow on where the Cubists left off,
but also it shows how painting has evolved in

the last seventy-five years. Between 1976
and 1987 Hockney, a close friend ever since
their first year at the Royal College together,
has been experimenting with photo-mon-
tages and prints. These works have been
heralded by some as the natural successors
to the great Cubist masterpieces. Kitaj has
been doing the same in oils. In *The Neo-
Cubist* Hockney is dislocated in a Cubist
manner to reveal more sides than normally
possible on a two-dimensional surface, but
the painting is not restricted by the rules of
Cubism. It shows Hockney stepping out
from a mammoth egg shape. He floats
forward like Botticelli's *Birth of Venus* and is
in a landscape rich with references to
Matisse, other Kitaj works, and his own
Splash paintings.

Kitaj as usual is best at describing his own
imagery. 'The "egg" shape,' he writes, 'is my
mimicry of that grey Cubist ellipse which
sometimes frames classical analytic Cubist
compositions. I meant the lush plant life to
stand for the artificial garden paradise one
finds in Los Angeles, and in Hockney's own
garden there. I began the painting as a nude
(of D. H.) about twelve years ago. It had
been in storage all these years—then a year
or so ago, when his dear friend Isherwood
died and Hockney related his last days and
hours to me, I got the old failed painting out
in order to transform it, with Isherwood's
ghost dislocating (as you say) Hockney's
form, after his newfound Neo-Cubism . . . I
even gave Hockney bathing trunks
(barely) . . .'

Hockney's many arms are firmly bound to
his side. He is tied by the limitations of his
art. Though he shares aims with Picasso,
Braque, and Hockney, Kitaj is not a Neo-
Cubist. His painting demonstrates the ulti-
mate failure of Cubism to resolve its spatial
context. He doesn't rely on a distortion of
perspective; he doesn't attempt to physically
force an extra dimension into the canvas. He

simply places the contrasting thoughts, references, and experiences on one canvas.

There is a rough irony when Kitaj says that, 'I believe you can invent yourself'. It is the cruellest slap against Judaism. It is more in line with Bacon's Nietzschean stance and his need to constantly re-invent. 'Rembrandt,' Bacon observes, 'painted his portrait throughout his life and made himself different every time, re-made his appearance.' **Howard Hodgkin** (born London 1932) talks in precisely the same terms as Bacon and Kitaj, but with a very different emphasis.

Hodgkin was never represented by Helen Lessore's Beaux Arts Gallery, which is partly why he is not normally considered one of the central figures of the School of London, but Kitaj chose five of his works for the *Human Clay* exhibition back in 1976. His paintings might not appear to have much in common with the other School of London painters, yet he has similar aims to Kitaj. He is looking for a new dimension and in doing so has forged a language as consistent and economical as Bacon's, Auerbach's, Kossoff's, or Freud's.

Hate! Resentment! Despair! It only needs

18 R. B. Kitaj. *If Not, Not*. 1976. Oil on canvas, 60 × 60 in (152.4 × 152.4 cm). Scottish National Gallery of Modern Art, Edinburgh

19 Howard Hodgkin. *Goodbye to the Bay of Naples*. 1980–2. Oil on wood, 22 × 26¼ in (56 × 66.7 cm). Private Collection, Chicago

20 Howard Hodgkin. *Dark Moon*. 1982–4. Oil on wood, 12 in diameter (30.5 cm). Private Collection

one look at *Reading the Letter* (Plate 4) to realize it is full of these and other powerful emotions. The difficulty comes with further investigation. Hodgkin's work refers to specific events and yet he rarely reveals the stories behind them. The viewer is forced to take the picture at face value, to learn the language, to look and look again. He has conjured a cocktail out of primitive forces. The pulsating columns of red patches are aggressive. There are details that might mislead. The viewer can never be certain he has fully cracked the code. For instance the artist doesn't associate green with envy, for him it is a colour of security. (He paints the walls of his house green.) One of his favourite colour combinations is green and black since as Bruce Chatwin recalled, 'Florence Hodgkin, his eccentric Irish grandmother, appeared in a black suit with a green hat, green artificial flowers, green blouse, green shoes, green umbrella, green bottles of champagne and a lot of green-wrapped presents in a green carrier bag.'

It is possible to walk past a Hodgkin, virtually oblivious of its presence. Indeed *Dark Moon* (Plate 20) and *Bust* positively irritate in the same way that the fisherman's fly tempts the dieting salmon. Once caught there is no escape. Parts of his paintings can confuse but never the whole. *Reading the Letter* has the blatant charm of a jewel.

Hodgkin plays cat and mouse with us. He creates barriers so that he can break them down. *Dark Moon* is antagonistic. It is a tondo of mawkish greys. It doesn't even have the nineteenth-century appeal of an Atkinson Grimshaw nightscape. There is a natural revulsion against the audacity of hanging this small, ugly object on the wall, but the eye is trapped. The warm red rim seizes attention and the magic of a cloud-covered silver moon is evoked. He personally selects the individual panels for each subject and varies the size accordingly. His paintings are

the antithesis of the modern production line of standard museum-size canvases. In the 1960s and 1970s he adopted the late sixteenth-century painter's attitude to *trompe l'oeil*, whilst Minimalism and Conceptualism were in ascendancy. There is a further twist. The visual wizardry is turned upon itself, so that it is no longer a tool of escapism but emphasizes the flat surface. The blue strip in the centre of *Goodbye to the Bay of Naples* (Plate 19) throws the sea forward and distances the sun-filled clouds, at the same time counterbalancing the camouflaged frame by resisting three-dimensional allusion.

Talking about art, as Hodgkin's picture of that title suggests, is a secondary activity. No amount of analysis can give the same understanding as that of standing in front of his work. The Bay of Naples has inspired a number of great writers, but the ebullient nostalgia and *joie de vivre* of Hodgkin's paintings still give a fresh perspective. The grammar of his paintings, the various signs and forms that occur again and again, provide intriguing study, but the works themselves surpass the sum total of marks. Despite and because of their many allusions they break down the barriers between people and art.

Kossoff's work has a monumentality rivalled by none of his contemporaries. His figures and landscapes possess an awesome solidity. They are immovable icons. I have separated him from Frank Auerbach, because despite the long-standing friendship and many similarities, **Leon Kossoff** (born London 1926) leaves a substantially different legacy to younger artists. Kossoff and Auerbach attended Bomberg's classes together, they sat for each other to save the price of a model, and both used fields of thick paint in the late fifties and early sixties. Kossoff forces images out of the paint; he talks of paintings making themselves, but he

covers his tracks to ensure that the iconography of the picture overpowers all other considerations. The medium and technique are ultimately restrained by the scale of the artist's vision.

Kossoff describes his method of painting in relation to two works, *Nude on a Red Bed* (Plate 23) and *Children's Swimming Pool, 11 o'clock Saturday Morning* (Plate 21). In a recent letter to his dealer he wrote, '*Nude on a Red Bed* was worked on for five to six years. I did other versions on the way but only one other is left, sometimes I let the board dry out for a while but it was a sustained effort with

Peggy sitting two or three long mornings a week and some afternoons. It seemed I would never finish it and it was torture for her. On the day it was finished I worked all the morning heaping up the paint, then in the afternoon I scraped it all off and in less than fifteen minutes the painting appeared. I was so surprised by its lightness after all the turgidity that I scrawled my signature along the bottom of the painting thinking it would hold it up or pin it down. It is the only time I have signed a picture.' No one can be left in doubt over the outline of the nude. Despite the explosive activity of the paint in the red

21 Leon Kossoff. *Children's Swimming Pool, 11 o'clock Saturday Morning.* August 1969. Oil on board, 60 × 80¾ in (152 × 205 cm). Saatchi Collection, London

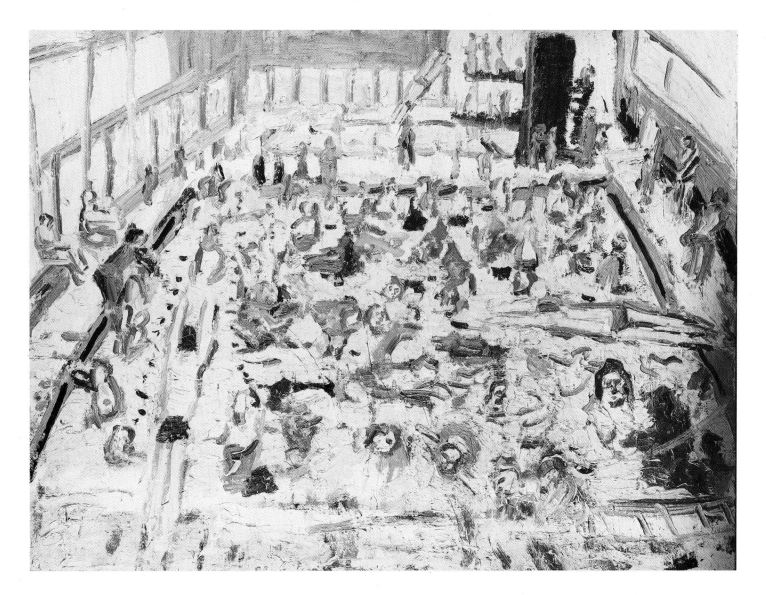

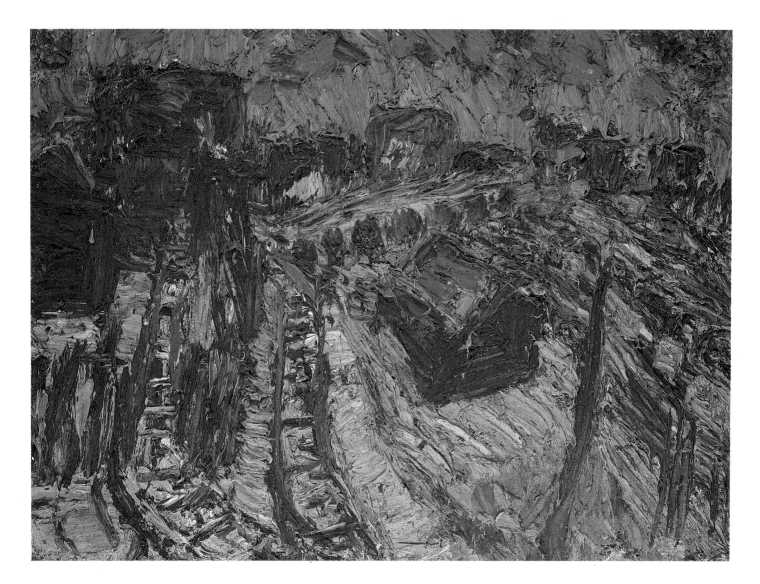

22 Leon Kossoff. *King's Cross, Dark Day*. 1967. Oil on board, 48 × 67 in (122 × 170.2 cm). Anthony d'Offay Gallery, London

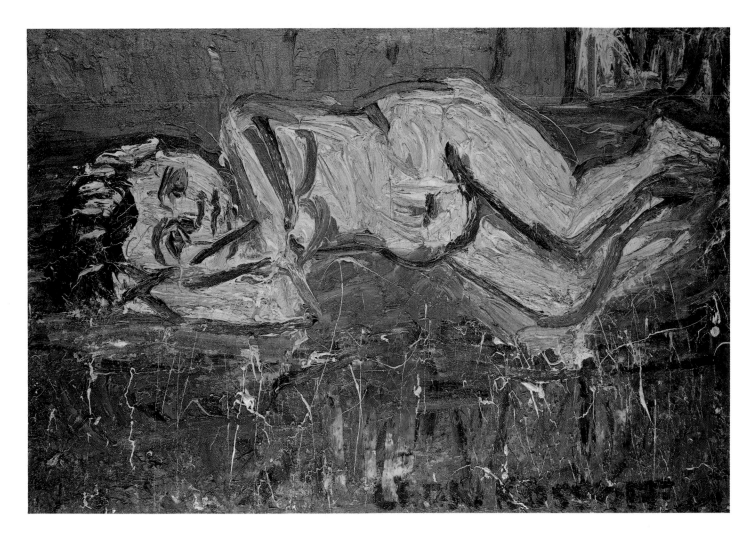

23 Leon Kossoff. *Nude on a Red Bed.* 1972. Oil on board, 48 × 72 in (122 × 183 cm). Saatchi Collection, London

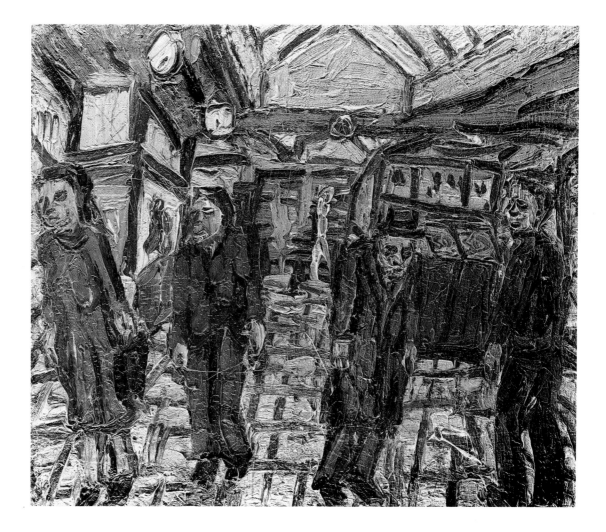

24 Leon Kossoff.
*Booking Hall, Kilburn
Underground*. 1977. Oil
on canvas, 42½ × 48 in
(108 × 122 cm).
Private Collection, Los
Angeles

bed, the picture is 'light'. The artist has succeeded in the creative act, precariously superimposing his order on chaos.

The making of *Children's Swimming Pool, 11 o'clock Saturday Morning* was a similar story. 'I had been drawing at the pool for two previous summers and the paintings were terrible,' Kossoff's letter continued. 'On that particular Saturday morning I worked for a few hours and then scraped it all off. In frustration I went to the pool to draw. On my return, working directly from the drawing, the picture happened very quickly. The strange thing was that each mark in the drawing became an identifiable person in the painting. And so it is with all my so called "crowd" paintings. Although

made from numerous drawings done in the street over long periods of time, at the final moment each person becomes someone particular that I know. It is as though, apart from the obvious subject matter, these pictures are about the people in my head.'

Kossoff has always relied on the immense patience of his sitters. His mother and father have filled his work, majestically overflowing from prescribed space like Cimabue's *Madonna and Child Enthroned* in Assisi. The weight of the paint and the wild strands tie them to the ground. From portraits of his father dating back to the late fifties to those of Fidelma and his wife, Rosalind, there is a sense of the figure planted in the earth. The double portraits of his parents bring the

single figures into focus. They are embodiments of the way we live, but they are never sentimental. Like Isaac Bashevis Singer and Dostoyevsky, he conjures up an agonized, simple but dignified world. It was Singer who said, 'Only dilettantes try to be universal; a real artist knows that he's connected to a certain people.'

Kossoff was born in the East End of London, in the City Road near St Paul's, and his father ran a small chain of bakery shops in Hackney. Many of his paintings are of this area, but over the years he has spread over London, from Bethnal Green, the City to Willesden Junction, York Way, Dalston, King's Cross (Plate 22), and Kilburn (Plate 24). Dominating all are his constant anxieties, 'my dependence on sitters and drawing, my endless reflections, my self-doubts and my need to retain a view that a painter, in his lifetime, can't be anything more than an "ordinary" person who has the good fortune to be able to work on and with his self, his confusions and feeling of emptiness, in terms of making images.'

Kossoff's paintings and studies after the old masters are surprisingly consistent with his other work. The figures, so firmly entrenched in our minds, are transformed into Kossoff's 'people'. *From 'Cephalus and Aurora' by Poussin no 2.* (Plate 25) avoids theatricality though it is a subject with far more activity than he would have naturally chosen.

The rigours and regularity of Kossoff's technique and the simplicity of the image has led some to accuse him of formula painting. In as much as two screams might

25 Leon Kossoff. *From 'Cephalus and Aurora' by Poussin no 2.* 1981. Oil on board, 36½ × 48½ in (92.5 × 123 cm). Private Collection

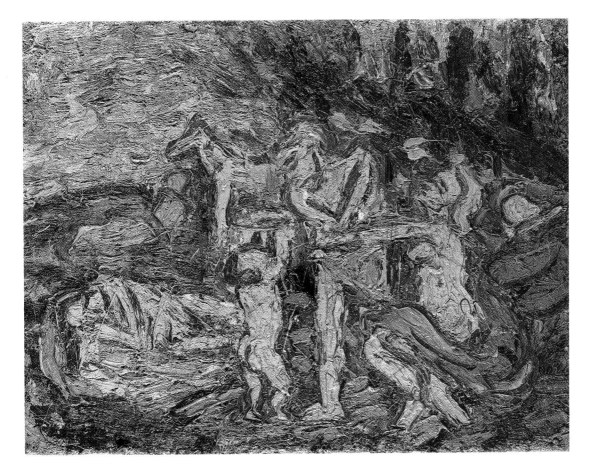

sound the same they are right, but Kossoff ensures that one sees the anguish underneath. His art is no more repetitive than life itself.

Lucian Freud (born Berlin 1922) confronts the British tradition of painting. He taught at the Slade when William Coldstream's regime was new at the beginning of the fifties. By that time he had already learnt from the harsh stare of Stanley Spencer, the trapped interiors of Sickert, and the underlying ethos of the time that there should be no drama, that painting should not be the poor relation to theatre. He had taken a long look at the earlier British painting which Roger Fry had so honestly dubbed a minor school. He learnt much about the control of paint, but he was never to be bound by the derivative dependence on the French school. Freud uses a seventeenth-century Dutch painter to explain his deliciously ironic adoption and adaptation of the modern British tradition. 'Frans Hals,' he says, 'is not illustrative but always tells a story.'

Freud has an essential duality. Of Austrian Jewish extraction and the grandson of Sigmund Freud, he came to England as an outsider at the age of ten, yet has gained a thorough firsthand knowledge of its high and low life. He has been both part of fashionable Society and a recluse who paints the night away in his flat. This duality can be seen in the contrast between the extreme elegance of his drawing room with its Bacons and Auerbachs set against neo-classical, Irish and Austrian Empire furniture and ten yards away the starkly lit rubbish heap of his studio. Intentionally he has left his studio as an unconverted room to provide the setting for his interiors. In one corner there is a mass of discarded paint-clotted clothes bearing witness to his labour.

Freud has two marked styles of painting, echoing Velazquez and Frans Hals in the dichotomy between the smooth and rough-hewn. His fine brushwork is clearly displayed in the stolen Tate portrait *Francis Bacon* (Plate 28) (which is actually painted on copper). The care involved in his handling of paint demands comparison with Dürer and other masters of the Northern Renaissance. His approach though is far bolder than it first appears. Individual hairs are depicted in minute detail, only to be juxtaposed with the careless fall of a whole lock. It is tempting to divide these styles into periods, but he has used both throughout his career. There are intimations of the brush work of *Large Interior W.11 (after Watteau)* (Plate 27) in *Man in a Striped Shirt*, which was painted forty years earlier.

Robert Hughes, who has dubbed Freud 'the greatest living realist painter', praises *Large Interior W.11 (after Watteau)* for asserting 'the advantages of scrutiny over theatre, without for a moment falling into the formalist trap of regarding the body as a mere inventory of potentially abstract forms, or the idealist one of mistaking it for a cultural construct without pores or orifices, without the sag and sheen of flesh—without, in sum, the humanity that Freud's art so alertly hunts from the body's cover.' Freud equates paint with life. He explains how he uses Cremnitz white for the basic pigment in the depiction of the human body. 'I wouldn't use Cremnitz on anything that wasn't alive,' he says; 'I use it for flesh, or even on the hairs of a dog, but never, for instance, on a woman's dress.' His nudes are pulsating masses of paint. *Esther* (Plate 7) is more like the master-work of a surgeon's scalpel than a painter's depiction of his daughter.

Freud refuses to dwell on technique. The image is far more important to him. His demands on his sitters are legendary. Baron Thyssen reports spending 150 hours in the studio and the five members of the Cavendish family recall an average of thirty-two sittings each. His devotion to his medium

26 Lucian Freud. *Painter and Model.* 1986–7. Oil on canvas, 63 × 47½ in (159.6 × 120.7 cm). Private Collection

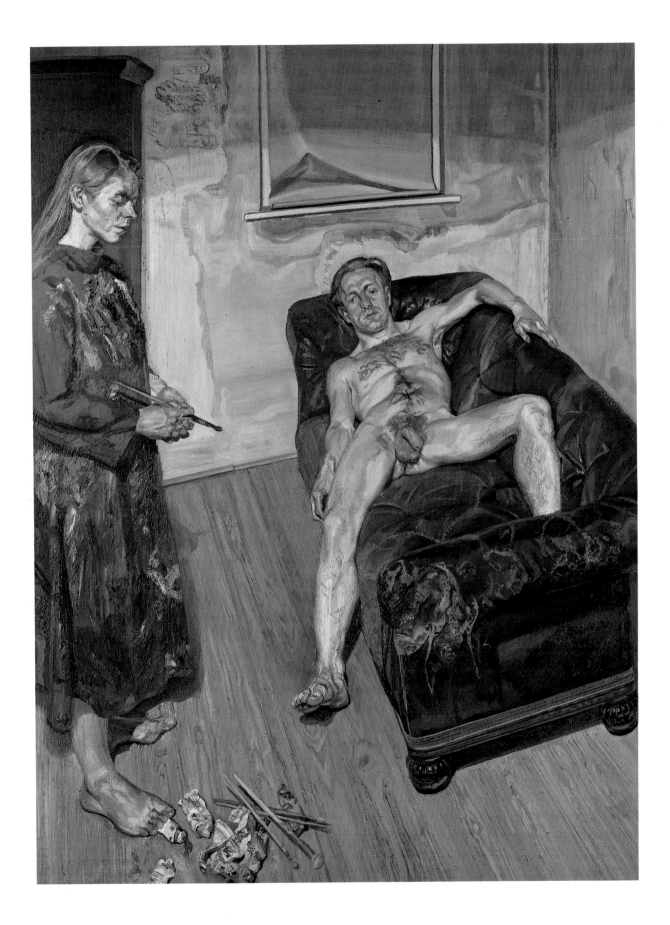

27 Lucian Freud. *Large Interior, W11 (after Watteau)*. 1981–3. Oil on canvas, 73 × 78 in (185.4 × 198.1 cm). Private Collection

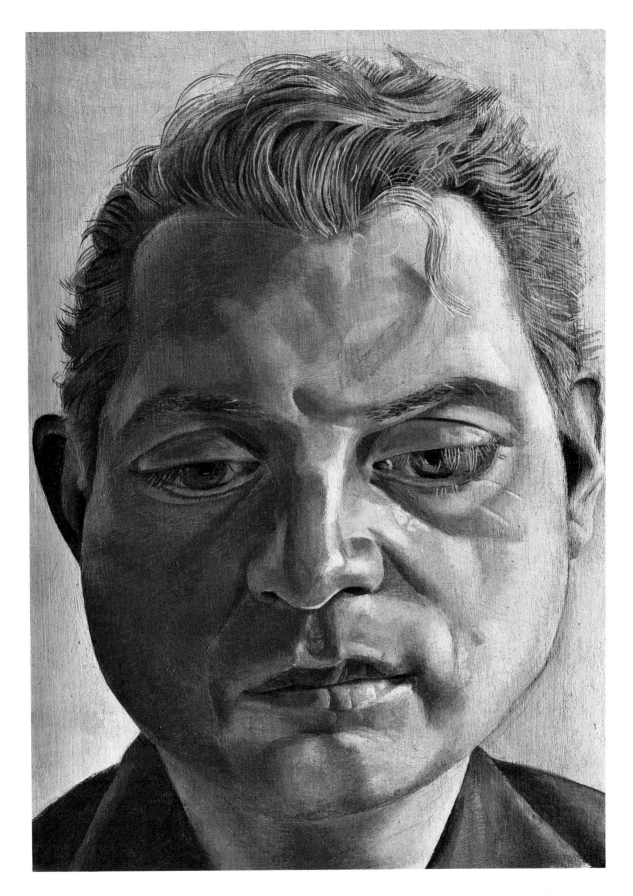

28 *Lucian Freud*. Francis Bacon. 1952. Oil on copper, 7 × 5 in (17.8 × 12.8 cm). Tate Gallery, London

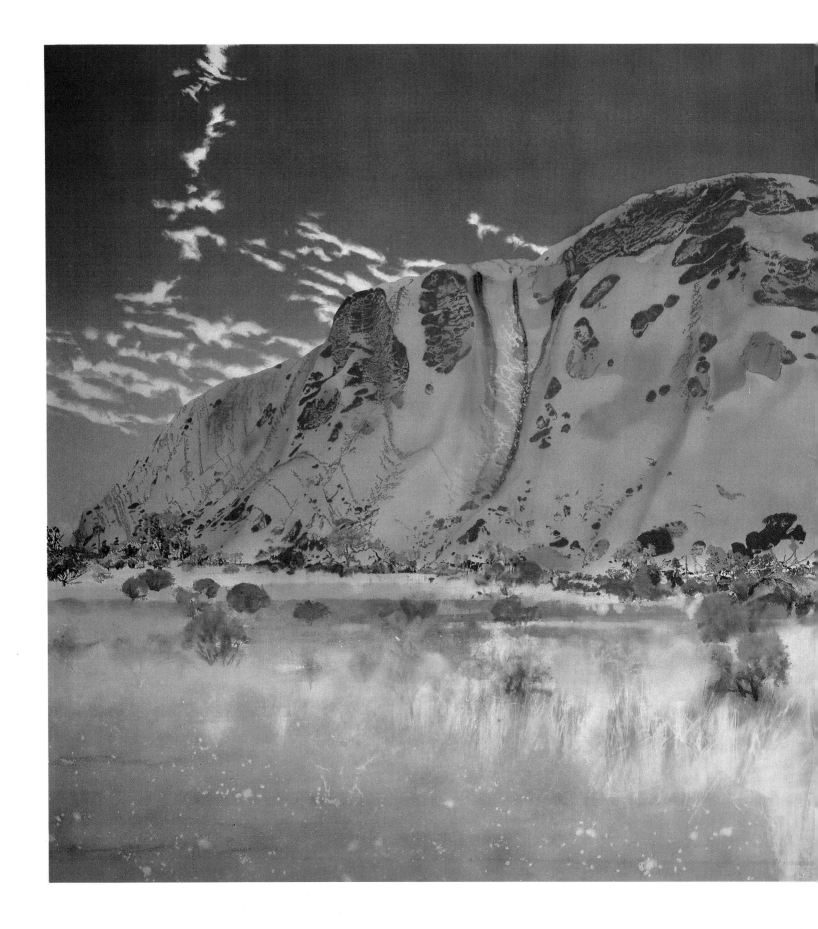

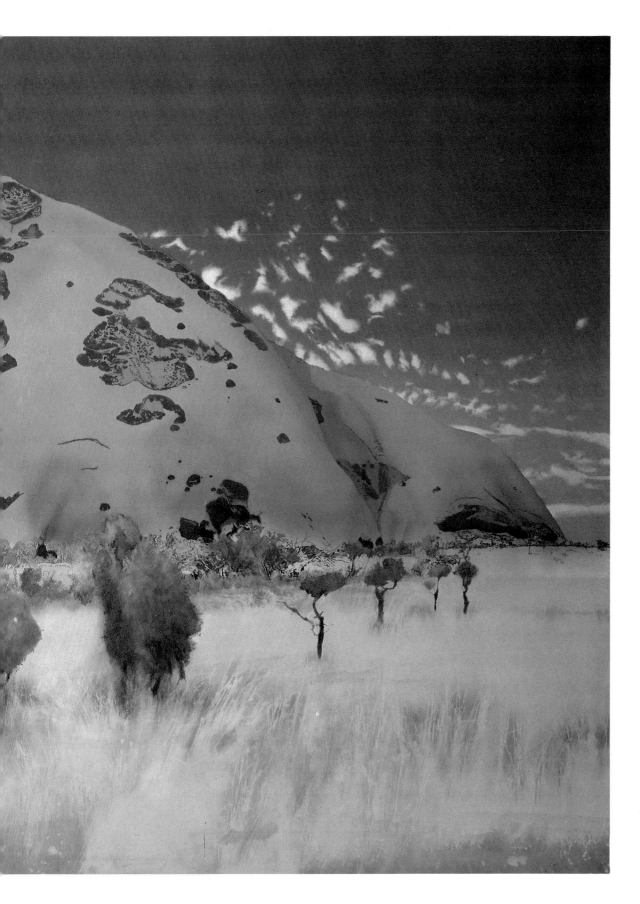

29 Michael Andrews.
*The Cathedral, North-
East Face Ayers Rock.*
1984–5. Acrylic on
canvas, 96 × 168 in
(244 × 427 cm).
Private Collection

appears unlimited, but he objects to an overemphasis of it. 'After all,' he quips, 'most paintings have been made with paint.' He never allows the paint to infringe on the image and relies on the vitality of the image itself to keep interest in his pictures. He talks of producing, 'images that it is difficult to imagine didn't exist before.' He is far from being an idealist; nevertheless he chases 'ideal' images. He has a physical hunger for unforgettable pictures.

Freud shocks. He has made some of the most startling images of the last thirty years: *Interior in Paddington; Large Interior W9; Naked Man with Rat; Naked girl with Egg;* and *Painter and Model* (Plate 26). Art historians, however, will never be content merely chronicling sequences of images. For them Freud's paintings in the early sixties are crucial, when he took paint and turned it into flesh. The series of self-portraits best illustrate this. *Man's Head (Self Portrait 111)* (Plate 30) would have us believe that Freud himself is built of paint.

Pupils at the Slade during Freud's visitorship included Michael Andrews, Euan Uglow, Victor Willing, and Paula Rego. Though Willing's own vision was swamped for many years by the Slade tradition and his mature art of the mid-seventies is a mocking rebuke of it, he far from condemned the Principal, William Coldstream. 'Coldstream was a new boy too,' he reminded us, 'when I went to the Slade in 1949. He didn't want people to say that he was just doing the old Euston Road bit all over again. He wanted to hear people say that this was an art school which would be a suitable nursery for the young artists of the next generation. He thought we should be doing modern art. Now he didn't know what that modern art was going to be and might not have accepted Alfred Barr's idea of it, but he knew he wanted to have talented people who would not feel constrained by rigorous training.'

Lawrence Gowing looks back at this as a golden age. 'Occasionally art schools are the centres of development that retain a lasting generative significance,' he writes. 'In the early 1950s the Slade School must have been such a place.'

From his college days **Michael Andrews** (born Norwich 1928) has been heaped with accolades. He won a prize at his diploma show in 1952, was awarded the Prix de Rome, included in *Four Young Artists* at the Beaux Arts Gallery and within ten years had painted *The Colony Room* (Plate 3), the 'official' picture of the School of London. Yet it is possible to argue that both Michael Andrews and Victor Willing took decades to break away from the strictures of their training. An anecdote from Willing bears witness both to this and to the liveliness of the Slade. 'When I was a student at the Slade,' he remembered, 'we had a sort of Brains Trust and David Sylvester was the Chairman and the other brains were Francis Bacon, Graham Sutherland, Lucian Freud, Rodrigo Moynihan—he was the Professor then at the Royal College of Art—and in the audience were myself and Michael Andrews and the Cohen brothers, and I think probably a few chaps turned up from the Royal College. Of course Coldstream was in the audience as well. At one point I asked some question about the intentions of the artists and I found they were all shuffling their feet so to speak. They weren't facing the question head on. I got rather impatient, being at that time a rather arrogant sort of student, and I upbraided them for not getting on with it, and not saying clearly what they were doing and what they meant. I was answered by Graham Sutherland who said, "Painters don't always know what they are doing when they are doing it. They discover what they mean after they have done it." I think I felt suitably reprimanded on the occasion, but it took me about twenty years to discover for

myself the truth of the remark.'

In the introduction to Andrews' 1980–1 Arts Council catalogue, Lawrence Gowing wrote, 'he imagined that he had an identity problem about his own work—that notorious bogey of talented students, which no one would remotely associate with even the earliest works of Andrews.' I would. Much of his first thirty years' work vacillates between influences, without confirming the early promise of paintings like *August for the People* in which he feared the standing figure was a travesty of a Bacon. Ironically, despite its references to Seurat and Picasso, it is one of his more original works; there are similarities to later Kitajs. He hasn't always fully digested his influences, now Bacon, now Uglow, now Coldstream. Giacometti figures slice *Good and Bad at Games* and the *Digswell Man* reverts to early Freud. 'I love a calculated risk,' he maintains, but in the past there have been too many unresolved pictorial problems, naive clashes between the traditional and the new.

Andrews was a beautiful and imaginative technician from the start. 'I remember him doing a drawing,' Willing recalled. 'There used to be an Antique room, rather boring and dead. Then they moved in lots of plants, which Sam Carter [a teacher] would water, and tanks of fish. It became much more interesting then. Michael Andrews produced a very moving, most beautiful drawing of a plant, which he had made up. There he was surrounded by plants, but he decided none of them looked quite the way a plant ought to look. So he made one up. So that made him really quite an object of interest.' The reputation of this characteristically British painter ironically has been re-affirmed by a series of paintings in acrylics based on the great natural symbol of Australia.

In his paintings of Ayers Rock (Plate 29) Andrews has found a subject of suitable scale, colour, and significance to raise the

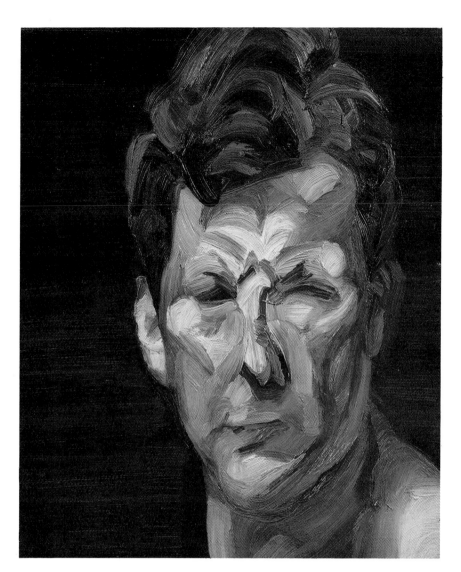

level of his preoccupations. His interiors and domestic paintings denied him the opportunity to openly engage with the universal questions with which he has always been concerned. He had painted within a prescribed pattern of thought and became a pasticheur of Englishness without even rising to the level of satire. Australia, however, appears to have rescued him from the artificiality of self-inflicted rules.

Victor Willing (born Alexandria, Egypt 1928, died 1988) has never been counted in the School of London, but he is a vital link between Bacon, Freud and the subsequent

30 Lucian Freud. *Man's Head (Self Portrait 111)*. 1963. Oil on canvas, 12 × 10 in (30.5 × 25.4 cm). National Portrait Gallery, London

31 Victor Willing. *Place*. 1976–8. Oil on canvas. 75¼ × 167¾ in (191 × 426 cm). Private Collection

32 Victor Willing. *Head VI*. 1985. Oil on canvas. 17¼ × 15½ in (43.8 × 39.4 cm). Private Collection

main stream of painting. The Slade tradition
swamped his early paintings but later he
adapted it to suit the ambitions of a School of
London painter. He took a formula and
twisted it so that it gave him a framework for
high emotion. Many years in Portugal run-
ning his father-in-law's factory cut into his
mid-career, but when the Revolution of
1974 forced him back to Britain permanent-
ly it was with sensational results. Diagnosed
as a sufferer from multiple sclerosis he
described his confrontations. 'We were
broke. We had no way of earning a living. I

had three children at school. I didn't know
what to do and started to panic, partly
because I felt that I had to try and do it now. I
knew I wouldn't be able to paint big pictures
next year. I did as much as I could, but I
didn't expect to have an exhibition.'

Place (Plate 31) is a hauntingly philo-
sophical response to his altered circum-
stances. Several of the drawings for it have
figures in them. One is called *Place of Exile*
but as Willing said, 'When I came to do the
painting I didn't want it to have an autobio-
graphical flavour. The fact that I had come

away from Portugal might have made it seem as though it was a lament.' None of the seventies paintings has complete figures. Years before his Slade teachers had required 'paintings with no implicit drama. Any suggestion of an event was rigorously excluded.' His belated reply was to resurrect the advantage Vermeer's timelessness has over a Poussin and combine it with an emotional tension. 'If there are figures,' he said, 'there is an implication that somebody is doing something to somebody. Everything in the painting is part of the drama. Therefore it is better that the distinction between people and objects disappears.' He has excluded figures, but littered the canvas with clues to their existence. *Place* is like a stage set; it is a setting in which our minds cannot help but enact a drama. At that time the sets came as whole manifestations; the artist was literally seeing visions.

'It wasn't like St. Paul on the Road,' said Willing of the hallucinations that he had from 1976 to the end of the decade. 'When I had my studio in Stepney, I found that I was feeling very tired, tired but not sleepy. I had had disturbed sleep and would sit in an easy chair and look at the wall in front of me, resting. And I began to get the impression that the wall in front of me dissolved and an enormous hole, about the size of my canvases, appeared and I could see through the wall a room on the other side. . . It had never happened previously in my life, but of course we all dream and we all day-dream. So when something like reveries begin to form images, and you are trying to find suitable images to paint, it doesn't suddenly strike you that something peculiar is happening.'

Willing didn't have a monopoly in the use of reverie in painting (Andrzej Jackowski,

Ken Kiff, and Arturo Di Stefano all refer to Bachelard and his views on it), but his reveries were responsible for injecting a new freedom into British painting. It is tempting to attribute his new bright colours to his sun-drenched days in Portugal, but he denied it. 'When I was there,' he pointed out, 'I painted in rich, dark browns. Very bright light tends to wash out colours. People spend a great deal of their time in darkened rooms.' The seventies colours came naturally with the new grandeur of vision.

Whilst the eighties saw Willing's physical condition steadily encroach on his ability to use a brush, his full power was mysteriously unleashed. He admitted that the drawings, *Masks*, and the paintings, *Heads* (Plate 32), are a description of the disintegration of his body. These forms at last confirmed the screeching nerve-ends of implied figures in the deceptively calm earlier paintings. *Place* is so well ordered that it could almost be Plato's ideal place. Only the few abandoned objects deny it. The artist is holding up this order to mockery, to reveal the full extent of the chaos that lies behind our ever limiting brains. As he preached, 'There is a crying need for anarchists.'

Bacon disrupted the face to unleash emotions many years before Willing's heads, masks and later works (Plate 33). Both of them have plundered from the rich and endless source of Picasso, but Willing followed the cardinal rule of re-invention. 'I wanted to do some faces,' he said, 'but I was very aware that we can't see much in a face.' The masks are hiding something, which is clarified by the heads. 'They cannot tell you much about a personality; they are anguished images.' They are the Greek chorus line, the carriers of concentrated emotion.

57

34 Gillian Ayres. *Lucas*. 1985. Oil on canvas. 96 in diameter (243.8 cm). Private Collection

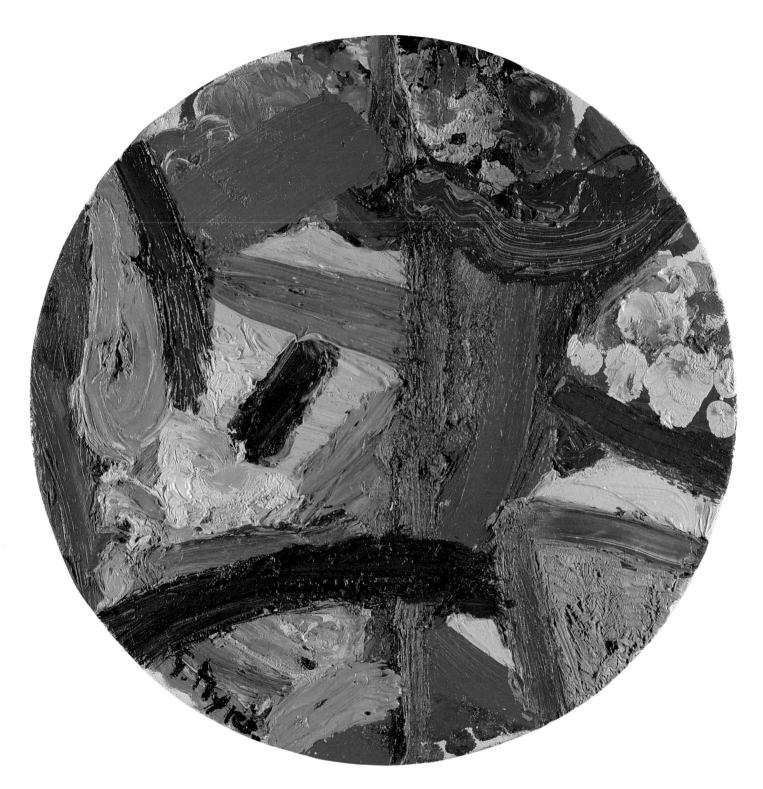

35 Gillian Ayres. *Helicon*. 1983. Oil on board. 10 in diameter (25.4 cm). Private Collection

CHAPTER TWO

Curtain of Flesh

Gillian Ayres (born London 1930) is the most direct British heir to Jackson Pollock. In 1960 and 1961 several of the other artists who banded together to show large abstract paintings in the *Situation* exhibitions could have equally laid claim to the title, though none produced a work as close to Pollock or De Kooning as *Cumuli* (Plate 36). Her importance, however, doesn't derive from her immediate development of Abstract Expressionism, which was not that far removed from American Post-Painterly Abstraction. Her significance lies in the way she has stayed true to abstraction over thirty years and yet made paintings in the spirit of the hardcore School of London.

Studying at Camberwell in the late forties, she remembers Victor Pasmore, a late convert to abstraction, 'wandering about muttering that easel painting was dead'. In the fifties and sixties only Roger Hilton amongst British painters received her unreserved attention as, 'someone who spoke well about art'. The vital impetus came from America. In 1957 she saw the Hans Namuth photograph of Pollock working on the floor. For a while she emulated this 'arena in which to act when painting on the floor'. She persisted with paint when most around believed that Pasmore's prediction had come true. By the early seventies fellow teachers at St. Martin's

were warning her students, 'Don't listen to her, she'll make you paint.'

Ayres has helped bury the great debate between abstraction and figuration. Much like Hodgkin she has formed her own language with its rigid laws and regulations. *Helicon* (Plate 35) is built up of remarkably few basic forms, ones which become more and more familiar as one looks at her other pictures. The difference between her work and that of Howard Hodgkin's is that he is a figurative painter and she an abstract. Hodgkin's paintings refer to a specific event, hers do not. She is an important precursor to the young generation of painters like Thérèse Oulton, Hughie O'Donoghue, and Arturo Di Stefano who balance on the fence between abstraction and figuration.

Matisse's late cut-out figures offer a key to understanding her paintings. She produces a similar energy to that of Matisse's from equally simple components. Her paintings are not limited by the space allocated them, they threaten to break off the wall. She refers to Roger Hilton's statement in *Nine Abstract Artists*, 'I have moved away from the sort of so-called non-figurative painting where lines and colours are flying about in an illusory space, from pictures which still had depth, or from pictures which had space in them, from spatial pictures in short, to space creating

36 Gillian Ayres. *Cumuli*. 1959. Oil on hardboard, 120 × 126 in (305 × 320 cm). Knoedler Kasmin. London

37 John Walker. *Untitled (Alba with Skull)*. 1978–82. Oil on canvas. 83½ × 57¾ in (212 × 146.5 cm). Frederick Weisman

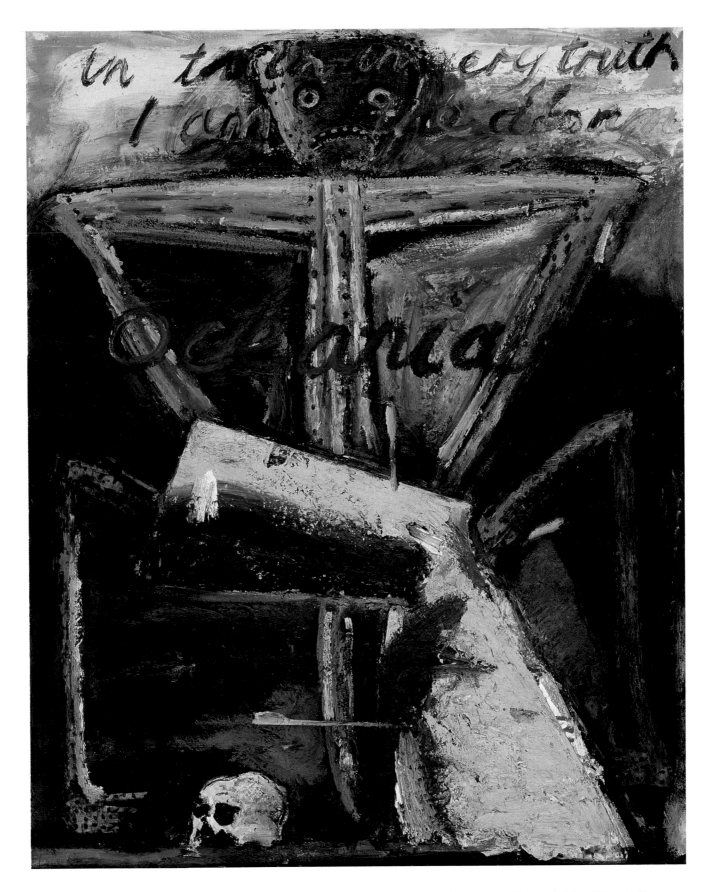

38 John Walker. *Oceania My Dilemma*. 1983. Oil on canvas. 96 × 78 in (243.8 × 198.1 cm). The Edward R. Broida Trust, Los Angeles

pictures. The effect is to be felt outside rather than inside the picture: the picture is to be not primarily an image, but a space creating mechanisms.' Ayres' work is extremely positive; it is not born out of crisis like Auerbach's. She is a Romantic. Her greatest ambition is for her 'paintings to have the same effect as Chartres or a late Titian'. The west façade of Wells Cathedral, perhaps England's most magnificent medieval showpiece, has a tondo named in its honour, *Wells*.

Three events between 1977 and 1981 led to Ayres' Welsh pictures, the summit of her achievement to date. The first was that she turned away from painting with acrylics. 'The increased knowledge of an artist somewhat "invisible" in England, Hans Hofmann,' Tim Hilton wrote in her Serpentine catalogue, 'suggested a use of oil that both emerged from Abstract Expressionism and resumed a great amount of classical European art.' The second event was a visit in 1979 to Florence from which she returned with a determination to paint tondos. Her first tondo, *Ah Mine Heart*, used the top of a Georgian table as the panel. 'It was worth far more than the painting at the time,' she admits. The discovery of round and oval compositions was an essential catalyst to her, abetting the natural tendency for the paint to explode like a catherine wheel (Plate 34). Thirdly in 1981 she gave up her post as Head of Painting at Winchester and went to Wales, where she lived for six years (she now lives in Cornwall). It is appropriate that she has set up home in far flung outposts of Britain, because she has done much to assimilate the quieter voice of provincial painting into the international cauldron.

John Walker (born Birmingham 1939) may have only spent six years living permanently in London (1964–70) but he touches on the School of London's heart. Since the early seventies he has built much of his career in Australia and the United States, but the 1985 Hayward Gallery Exhibition was a bold confirmation of earlier achievements. The three series of paintings, *Alba* (Plate 37), *Labyrinths*, and *Oceania* (Plate 39) were like a concert pianist playing his scales in public. It was the natural conclusion to talk of 're-inventing oneself in paint'. The painter's aims unfold with the series.

Walker has a direct connection with Pollock. Doré Ashton describes in the catalogue to *John Walker: paintings from the Alba and Oceania Series 1979–84* (Hayward Gallery 1985) how he is the guardian of a now destroyed Pollock. She talks of Walker 'hauling it [the Pollock] around in his mental storage-kit'. 'The title of the Pollock is *No. 12, 1952*,' says Walker himself. 'I believe it belonged to Nelson Rockefeller who had a terrible fire. The picture is reproduced opposite page 51 in Bryan Robertson's book on Pollock—a bible if there ever was one.'

Walker has always followed main stream developments very closely. Though he is neither a Londoner by birth nor choice, he is like a figure walking beside the eldest School of London generation. He shares many of their concerns and ambitions: he trusts paint, allowing it to work for him according to its natural properties; he is thematic like Auerbach, working away at a subject in the hope that it will produce an ever richer yield. Yet his subject matter is far removed from that of the isolated man. He paints about the clash of cultures as befits his nomadic existence. He allows his contact with aborigines and the Oceanic 'primitives' to clash violently with his understanding of Western civilization. This is most clearly revealed in the climax of his concerns, *Oceania My Dilemma* (Plate 38).

At the same time that Walker was showing in London, New York's Museum of Modern Art was holding *'Primitivism' in 20th-century*

Art, the most comprehensive analysis of the problem Walker portrays so personally in *Oceania My Dilemma*. Not only does Walker appear as the end of the line of Klee, Picasso and Dubuffet, but his broken imagery confronts Schnabel and the writing screams of Kiefer. Walker has shared an obsession for history and the way modern man fits into it with the major new international painters of the seventies and eighties. He personalizes the problem by claiming it as his own dilemma. The fetish Oceanic figure looms above the withered symbol of Goya's portrait of the Duchess of Alba. The biblical text, supposedly Matthew, 'In truth, in very truth I am the door,' is scrawled over and alongside the mask head whilst 'Oceania' is blazened on his chest. The Oceanic figure takes over the position of the door. Christ the

Door is left lying on its side and the remnants of Western philosophy lie at the feet of the creature in the form of a skull, the *memento mori*. Though *Oceania My Dilemma* is in many ways a summation of Walker's anxieties, its mood is not highly typical of his work. The Oceanic figure overpowers the spirit of contemplation that normally pervades his paintings. The dialogue in most of them is much more gentle, more reflective and the path of his brush plays a more important role.

Maurice Cockrill (born Hartlepool 1936) has certainly not received the attention or critical acclaim of Walker or Ayres, yet he too has given the School of London a new impetus at a late stage. He lived and worked in Liverpool from 1964 to 1982 and it wasn't until near the end of that period,

39 John Walker. *Oceania*. 1985. Oil on canvas, 96 × 120 in (243.8 × 304.8 cm). Private Collection

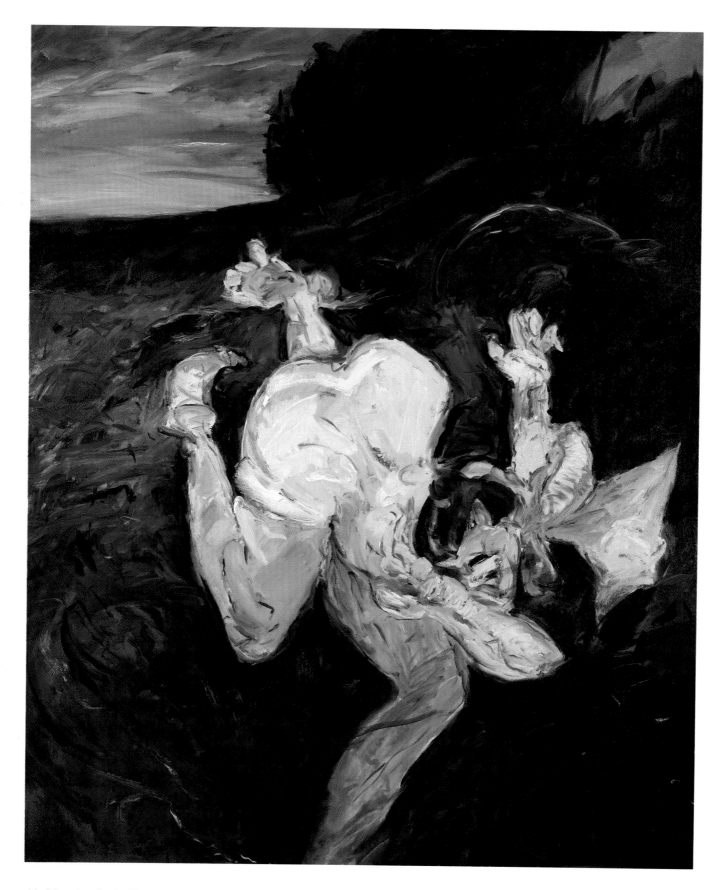

40 Maurice Cockrill. *Ophelia*. 1984. Oil on canvas. 73 × 60½ in (185 × 154 cm). Kunstmuseum. Dusseldorf

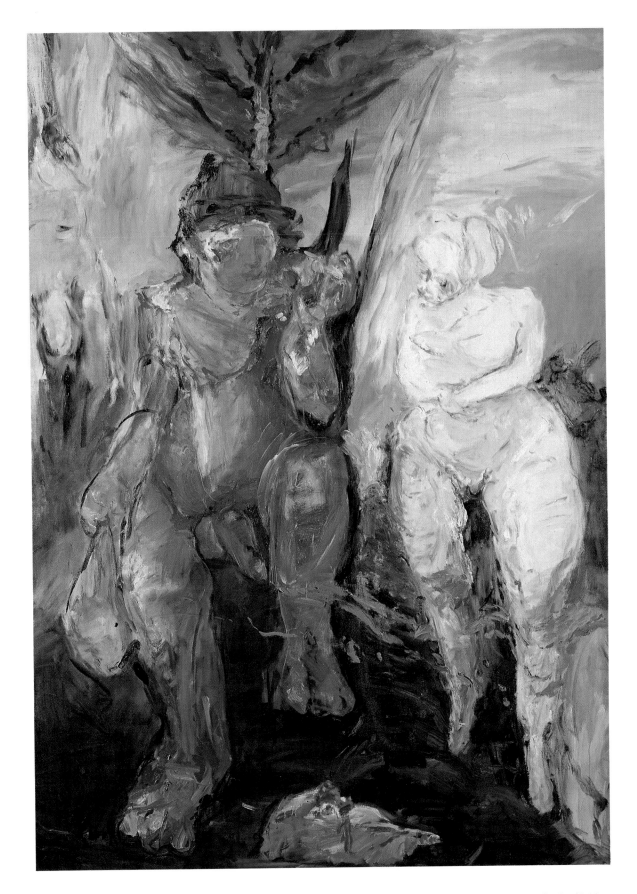

41 Maurice Cockrill. *Venus and Mars—Curtain of Flesh*. 1985. Oil on canvas, 102½ × 80¾ in (260 × 205 cm). Private Collection

just preceding his arrival in London, that he developed an art that lies somewhere between the twin towers of Auerbach and Kitaj. Once again it was the Americans who jolted him from a synthetic-realist style similar to Malcolm Morley's. He talks of De Kooning and Pollock's 'psychic automatism' and 'progressive shifting between abstraction and figuration'. The violent riots in Liverpool, which coincided roughly with his move to London, were echoed in his work.

'I was a middle-aged, embattled, self-sufficient artist,' recalls Cockrill, 'living in the centre of a threatened provincial city, which itself was about to erupt from its atmosphere of imminent social collapse into civil disorder.' He didn't use the street violence and urban decay as subject matter in his art, but there is a release of latent energy which recalls Bacon and Willing. Like both of them he started his artistic career later than is usual. He went to art school at twenty-five, having spent years working in an aircraft factory. The welling of tension resulted in two series of paintings after his arrival in London, the first of single heroines, mostly from Ovid's *Metamorphoses*, and the second of Venus and Mars.

Cockrill's importance lies in the way he ties many of the earlier School of London threads together. He gives the paint its head. Like Auerbach he lets it form images, but allows these to collide with other dispersed images. There is a traditional element in his use of landscape but in *Ophelia* (Plate 40) he disrupts both the body and the idyllic British panorama. The Shakespearian heroine's madness is consistent with the country around her. Water, land, and sky blend to form a mad landscape of the mind. Cockrill breaks the world down, dissecting it with the care of the Cubists, but binding it again by the use of fluid brushstrokes.

Auerbach and Kitaj pose a difficult problem: how to reconcile the production of images out of paint with the dispersal of the image. Cockrill's solution comes in the form of a curtain of flesh. The idea is taken from Titian's *Flaying of Marsyas* (Plate 42), which was on view at the Royal Academy's *Genius of Venice* Exhibition in 1983–4 and which had a great impact on many contemporary painters. In *Venus and Mars—Curtain of Flesh* (Plate 41) it is not only the paint that becomes flesh but the whole painting. It is raw, broken, and fragmented. At the same time it has the properties of paint, it is viscous.

Bacon's tight language restricts figures within interiors. If enclosing walls aren't available, he builds his own framework as in *Portrait of Isabel Rawsthorne Standing in a Street in Soho* (Plate 8). Cockrill sets his figures in open land and city spaces, but they

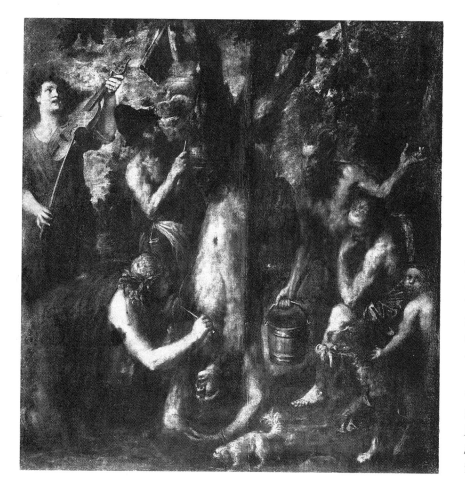

42 Titian. *The Flaying of Marsyas*. Sixteenth century. Oil on canvas, 83½ × 83½ in (212 × 207 cm). Kromeriz Statzanak, Czechoslovakia

serve the same purpose. He has transformed the countryside into a gym bar on which to sport his contorted men and women. It is the most natural stage (Plate 43).

The 'landscape' of **John Bellany** (born Port Seton 1942) is the sea. It and its moods form the framework for his paintings. He often expresses his personal anxieties and sets them against the background of a Scottish fishing village. Born on the south coast of the Firth of Forth, he has built his pictorial vocabulary from a fisherman's world, but he is not provincial. Goya's studies of the Peninsular Wars do not make him an artist only of interest to a few Iberian historians. Breugel's depiction of his own Flemish countryfolk doesn't diminish his cosmopolitan appeal; Munch's revelations on Nordic isolation don't cut him off from the rest of the world. Indeed these three artists have had more influence on Bellany than any Scottish painter. Like them he has taken specific local fears and aspirations and transformed them into a universal language. Sigmund Freud becomes as relevant as John Knox.

43 Maurice Cockrill.
After the Feast. 1984.
Oil on canvas. 27½ ×
35¾ in (70 × 91 cm).
Private Collection,
London

44 John Bellany. *Presentation of Time (Homage to Peter Paul Rubens)*. 1987. Oil on canvas, 96½ × 136 in (245.1 × 345.4 cm). Collection of the artist

45 John Bellany. *The Old Man and the Sea (The Departure)*. 1987. Oil on canvas, 68 × 60 in (172.7 × 152.4 cm). Collection of the artist

Bellany has had an eventful life. 'I have peaks of high intensity,' he reveals, 'then plunge into the depths. It is only through these extremes that my work is fed.' Whilst a student he sought basic principles to build painting anew, or as Bacon would say 're-invent painting'. Although he confesses, 'Bacon had a huge effect on me, when I was younger,' he had come to this decision by his own route. Alexander Moffat, his close friend at Edinburgh College of Art, recalls, 'I remember arguing that after Kandinsky, after Matisse, after Pollock, there was no way back, but eventually to break out from our formal straitjacket we would simply have to go back and look again at the entire history of modern painting.' Bellany has.

Bellany's early paintings are confrontational. Figures are shown full on, staring out of the picture, daring the spectator to meet their enquiring gaze. Moffat and he held rebellious exhibitions of their work during the Edinburgh Festivals of 1963–5, hanging their huge pictures outside the railings of the Royal Scottish Academy in the belief that, 'art was for everybody to see and not just for the chosen few'. After moving South to study at the Royal College in London and visiting Buchenwald concentration camp in 1967, his emaciated figures started demanding to know the reason for life, as the titles of his paintings reveal. The horrors of the concentration camp brought out fundamental questions: *The Obsession (Whence Do We Come? What Are We? Whither Do We Go?)*.

The triptych *Homage to John Knox* (Plate 46) reeks of Goya and much earlier frescos of the Last Judgement. The dangers of life at sea seem favourable compared to the in-growing guilt of the good Calvinist life with its threat of everlasting damnation. Death has always stalked the artist. He spent most

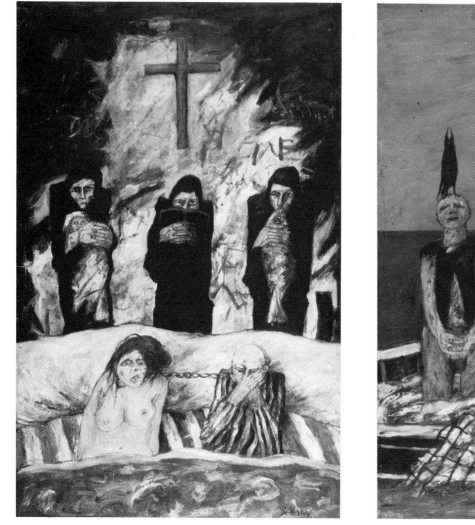
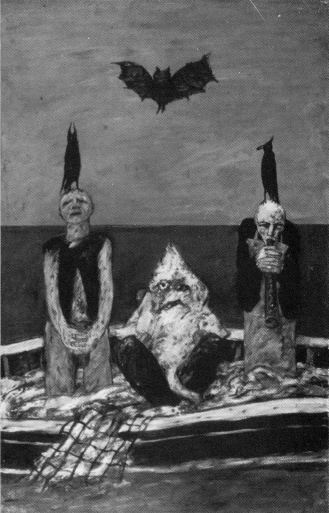

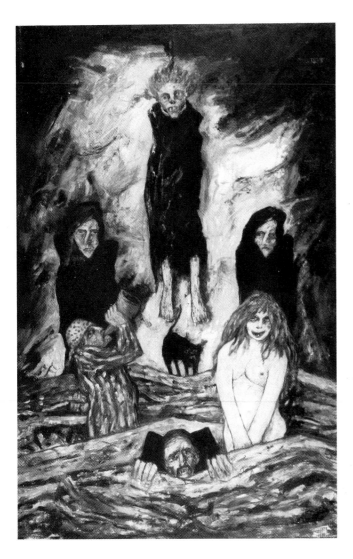

of his childhood in the village of Eyemouth in Scotland where his mother came from, which had lost half of its male population in a single fishing disaster in the year of his grandfather's birth in 1881. The visit to Buchenwald first released the need to constantly assess life against death. Then the end of the seventies and the beginning of the eighties brought the trials of Jonah. Bellany's second wife suffered from manic depression. Keith Hartley describes the paintings of the time. 'The paint spilled on to the canvases like blood, it was brushed on quickly in great arcs and swirls; the paint itself became the subject, the confrontation between reds and greens. These paintings are the nearest Bellany has ever come to Abstract Expressionism. It is perhaps not accidental that most of these paintings were done at a time when Bellany was showing for the first time in New York.' *Gambler* has more connection with Asger Jorn than directly with the American Abstract Expressionists. The urgent need to re-invent after Pollock couldn't be clearer. Everything is at risk in the face of death.

In *The Old Man and the Sea (The Departure)* (Plate 45) Bellany pays respect to Van Gogh, the epitome of the rebellious artist, echoing Bacon's *Studies for Portrait of Van Gogh*. There is one difference. Bellany is the fisherman artist carrying the sea on his back. The moods of the sea dominate his work. In 1986–7 the sea's surface seems glacially smooth, for 1985 marked the nadir of his tribulations. For several years critics had claimed that his work had become a weak echo of his former stern appraisal of himself. Tragedy brought his reply. His father and second wife died and he himself very nearly died after a serious illness. In *Presentation of Time (Homage to Peter Paul Rubens)* (Plate 44), Helen, his first wife, is seen giving the artist a second life. They were remarried. Yet the tension remains. The window on the left looks out onto the

46 John Bellany. *Homage to John Knox*. 1969. Oil on hardboard, three panels 96 × 63.2, 96 × 63, 96 × 63 in (244 × 160.3, 244 × 160, 244 × 160 cm). Collection of the artist

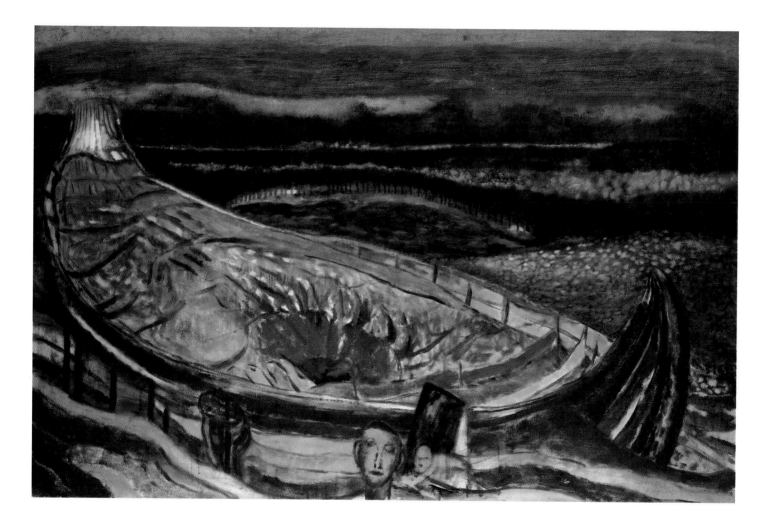

47 Andrzej Jackowski. *Settlement*. 1986. Oil on canvas. 60 × 92 in (152.5 × 233.5 cm). Arts Council of Great Britain

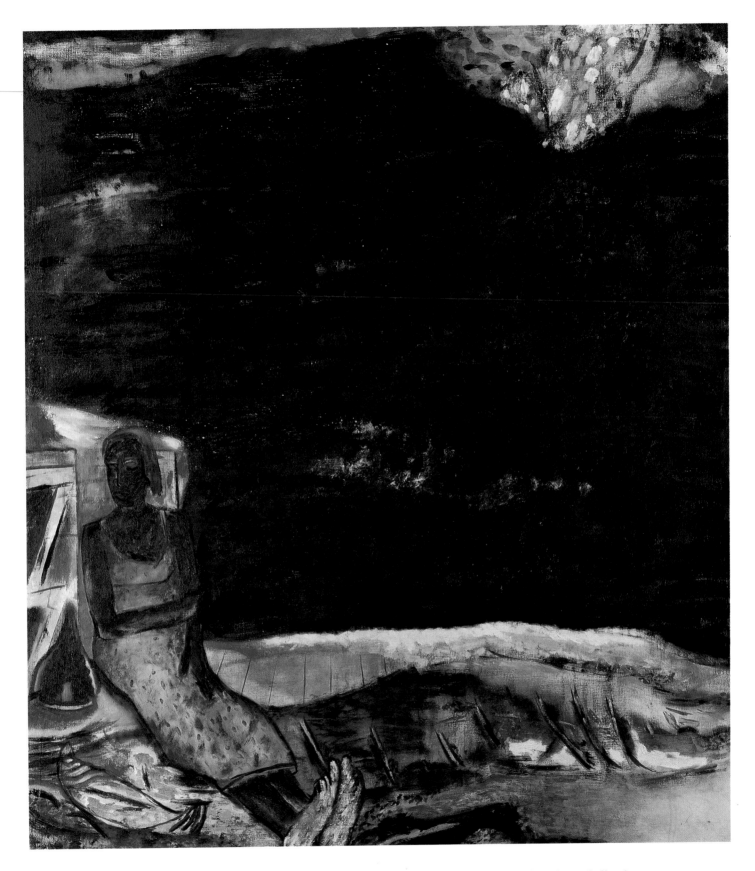

48 Andrzej Jackowski. *Long-Night*. 1985. Oil on canvas. 66⅛ × 59⅞ in (168 × 152 cm). Private Collection

protected estuary of the river Forth. A fishing boat glides towards Edinburgh. Everyone is looking to the head of the table, where Juliet (his second wife) looks on distrustfully. The owl, a portent of death, hovers above her. Bellany has been dealt all the aces, but behind him is the open North Sea. In a glorious sunset the deep blue sea is the very image of peace. The lighthouse is the only warning, scything the currently undisturbed water in two.

Andrzej Jackowski (born North Wales 1947) has occasionally been linked with Bellany. They both portray the transient nature of life; they even sometimes appear to be painting the same boat. Jackowski is of

49 Andrzej Jackowski. *The Vigilant Dreamer 11*. 1985. Oil on canvas, 72 × 60 in (182.5 × 152.5 cm). Private Collection

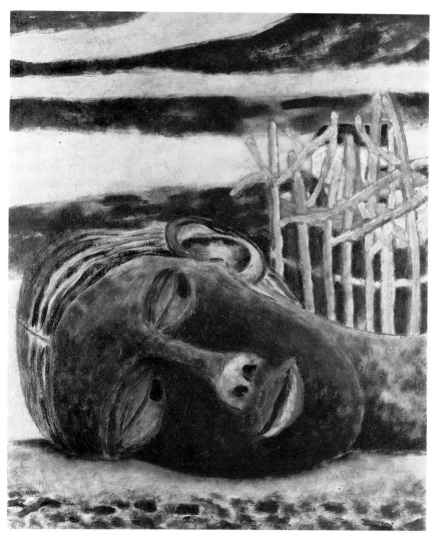

Polish extraction, and has a natural understanding of Northern isolation, but like Bellany he is drawn to the art of the South. They have a similar range of palette, but their techniques and moods could not be further apart. The luminosity of Jackowski's half-chalk ground—a traditional Italian method he learnt from James Trimble, a technician at the Royal College—intensifies the contemplative nature of his work.

Like Auerbach, Jackowski talks of 'paint unlocking feelings'. Like Kitaj, he encourages contrasting images. Like Willing, he refers to Gaston Bachelard's *Poetics of Reverie*, to the division between male dreams and feminine reveries. This distinction is vital. 'I have never worked from dreams,' he says, 'they are too narrative,' and strips his figures of personality for the same reason. He wants to go beyond his immediate circle and unlock universal feelings. *The Vigilant Dreamer* (Plate 49) series make the clearest statement about his views on reverie. The large childlike heads are having waking dreams. They appear to be in two worlds and therefore offer a way into the artist's inner thoughts of myth, memory, and intuition. By giving his paintings an almost unsettling tranquillity, he allows the contrasts within him to emerge. 'Reverse and opposite feelings come into view,' he maintains, 'desire and fear—closeness and separation—comfort and danger—love and death.'

Jackowski was brought up in a refugee camp in the North of England and many of his images refer to memories of that time. 'It was exile. My family lived in wooden huts for the first ten years of my life and now the place doesn't exist.' It does in his paintings. Time and time again wooden huts loom in the background, sometimes endowed with the dignity of a Venetian mansion, as in a Titian or Giorgione, at others transformed into the Tower of Copernicus. It becomes a domestic cart on wheels in *Going on* (Plate

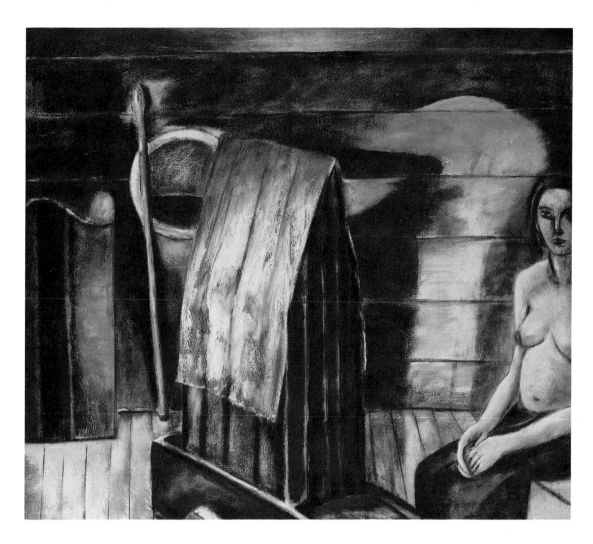

50). He is forced to carry his home around with him. 'I remember as a child living in the world much more,' he says. 'I felt more intimate with the world. There was a sense of it being a home.'

There is nothing new in Jackowski's use of his childhood for material. Many great names have been equally reliant on their early life. Proust is the obvious example and Jackowski could claim a certain Proustian lyricism. He is a fervent reader, particularly of poetry. Indeed he once gave up painting to be a poet and film-maker, but he maintains, 'Books work for me best when they inspire paintings rather than when I fully understand them.' He is careful not to let his reason hinder his painting.

Jackowski when discussing *The Vigilant One* and *The Vigilant Dreamer* explains how the images come. 'I knew there had to be a big shape at the bottom with something smaller at the top,' he says. 'The images came in that diffuse state, then it was a question of finding the precise shape. The weight of things meant it had to be heads. Or in *Downfalling*, where the woman is sitting there, very still, and the man is falling through the snow. I was lying there, dreaming away. Suddenly I saw a woman sitting there and the man falling in the snow. It wasn't an hallucination, but an awakening. Obviously they need working on, in paint, colour, and scale, but the image usually comes quite whole like that.'

50 Andrzej Jackowski. *Going on.* 1982. Oil on canvas, 52 × 60 in (132 × 152.5 cm). Private Collection

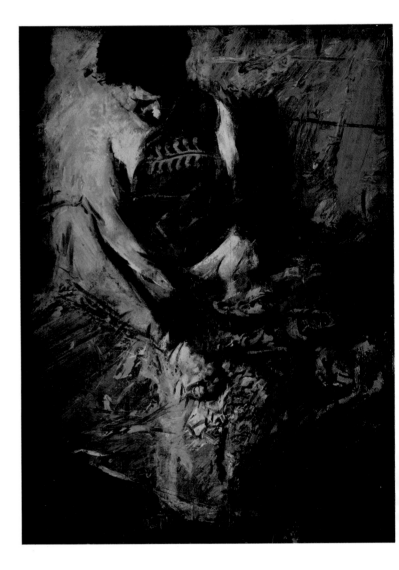

51 Robert Mason. *The Mask Left Bare*. 1985. Acrylic, pastel, and charcoal on museum board, each board 31¼ × 43½ in (79.4 × 110 cm). Anne Berthoud Gallery

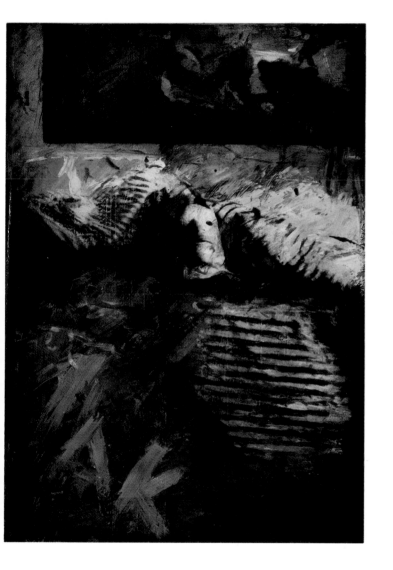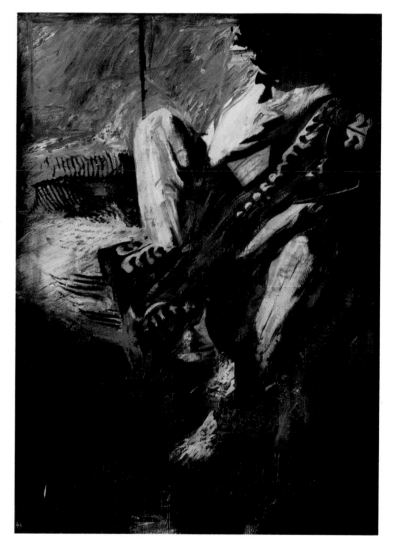

Objects recur in Jackowski's work till they become part of his regular building materials like the wooden hut, the Tower of Copernicus, and the Viking boat. He once chanced on illustrations of Viking discoveries in a magazine and though he wasn't particularly interested in Norse legend, the boat struck a note inside him (Plate 47). So much so that he appropriated the image for his own purposes. Freudians will immediately see a womb, but whatever one's belief, he has turned the boat into a part of his vocabulary much in the same way as an abstract painter might employ a particular form. He talks of using 'bricks of emotional feeling to construct paintings,' and admits he has to wait for them. 'I think of Rilke and his elegies. They are not his; they are a cry about the world which went through him.'

Jackowski's compositions have become much bolder in the eighties. *Long-Night* (Plate 48) could almost be the final word in 'pregnant space'. There are the usual elements: a still woman, a hut, bare boards, and a small Viking ship. There is no sign of travelling any more; even if the boat was seaworthy it is too small for the woman. Perhaps the figure has been shipwrecked, is cast into the middle of the night and onto this man-made island, but if so she is philosophical and even optimistic about it. The artist is a fundamental questioner. He keeps on returning to 'the cosmic feeling one has in childhood, of confronting the stars and asking where does one come from? What is it all about?' The cloud-burst of colour in the corner of this painting is the most positive answer.

Robert Mason (born Leeds 1946) is the most intimate and contemplative of painters. Primitive figures appear out of browns, yellows, and reds. There is a hint that at any time they may return back into the earth. The number of recognisable objects is strictly limited. Apart from crouching self-portraits,

there are letters, bones, and masks (Plates 52 and 53). 'We all wear a mask in a sense,' he says, 'underneath it we have much more complex characters than the world sees.' There are connections with Willing and Jackowski here, and an acknowledged debt to Auerbach, but it is Mason's own life, 'the family in holocaust', that provides the most accessible key to his work.

'The themes within the work,' Mason writes, 'reflect my preoccupation with the loss as a child of my entire family. From the age of three until fourteen, I was faced with their prolonged illness and eventual death.' He uses the mask to transcend our natural disguise, but it also has a very personal significance. 'I once saw the white mask. It is my sister, when she had just died. I went to see her. She was lying on her bed. It has taken on a number of roles. In one it is the inner soul, it is me and it represents death.' As in his paintwork there is an ambiguity in the way he uses the mask. Whilst his sister was dying, Coco, the son of the original Coco the Clown, made a visit to her and the artist remembers the face he wore. Edward Munch's paintings of his dying sister, which Mason encountered on his travels to Oslo in 1966, were the trigger. Throughout the late sixties and early seventies, he was looking for a more emotional art than he was being fed at Hornsey College of Art and then the British School in Rome. 'The cold world in which he was nurtured,' Doré Ashton writes, 'where, as he so often remarks, there was nothing but talk of the minimalists Judd and Morris—was unacceptable to his romantic temperament bestirred by tragedy.'

Mason's paintings are not trying to re-create a nostalgic mood. He excavates feelings. It comes as no surprise to learn that he arrived at painting through archaeology, sculpture, and finally collage. He paints as though he is physically trying to uncover layer upon layer of the world. His paintings

52 Robert Mason. *The Mask and the Stole*. 1986. Oil paint on acrylic ground, 42½ × 28¾ in (108 × 73 cm). Private Collection

53 Robert Mason. *Family Portrait V1*. 1986. Oil, acrylic, and charcoal on museum board, 47¾ × 33 in (121 × 84 cm). Private Collection

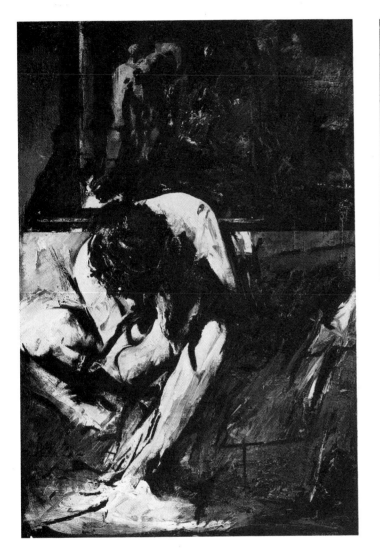 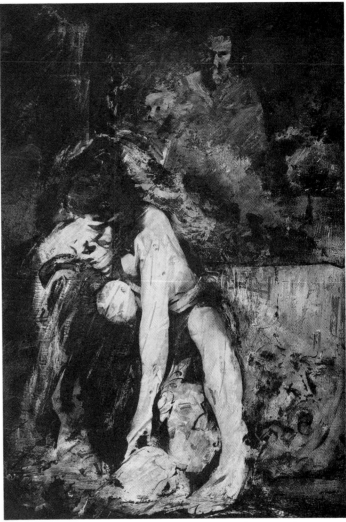

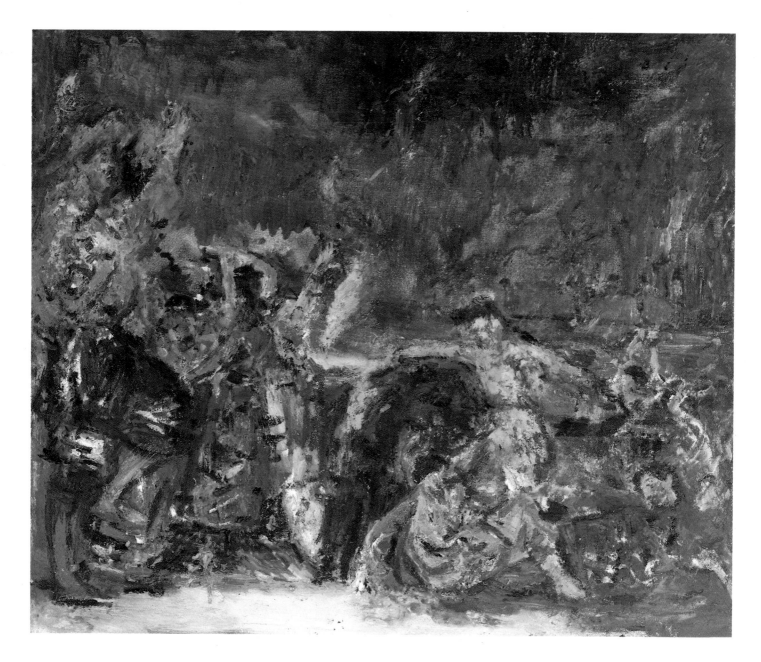

54 Terry Setch. *Trystan and Essyllt-Forest 1*. 1986. Oil and encaustic on canvas, 27 × 32 in (68.5 × 81.5 cm). Private Collection

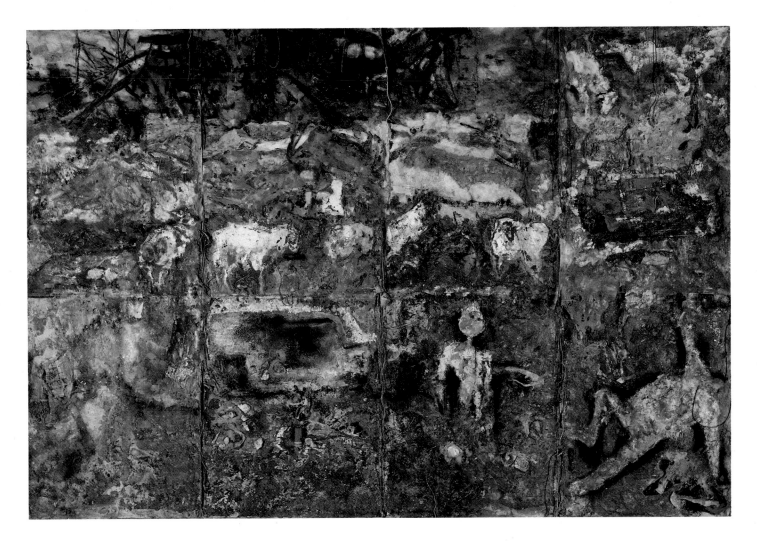

55 Terry Setch. *Touch the Earth again*. 1987. Mixed media principally wax with found objects on carpet underlay. 181 × 315¾ in (460 × 802 cm). Private Collection

are often like African masks in their entirety. He builds up planes of character, there are lines of chisel marks and daemonic exaggerations. *The Mask Left Bare* (Plate 51) recalls Picasso's *Demoiselles D'Avignon*.

Terry Setch (born London 1936) has the most physical involvement with landscape. He has combed Penarth beach in Wales ever since the early sixties for drift materials to put in his paintings. He works on the scale of theatre backdrops, tying pieces of rough canvas together like a trucker, then hanging them on a similar framework to those that fishermen use for mending their nets. He has an interest in politics: he based a series of paintings on the Greenham Common women, who have camped ever since the early eighties outside the Greenham Common American Air Base in protest against nuclear weapons. He invariably paints a primeval nuclear wasted earth. Yet he never preaches. 'I have a political life,' he admits, 'but that is only relevant in that it can affect the way I behave, how I live my life, and therefore enters the correspondence with the painting whilst I am painting. The landscape I paint is a scarred one. Scarred by local and international pollution, it could easily be totally contaminated, stripped of all life. Penarth beach is just a little piece of the world.' He is painting within the British landscape tradition, but involves the spectator by his own performances that owes a debt to Pollock.

'I put myself in the landscape,' says Setch. 'The canvas is the landscape, which is why I choose large drapes so that I can work literally within it. One of the most interesting moments in my development was seeing the film of Pollock working and talking about being in the painting. That still holds true and I am sure many pre-Pollock artists were in the painting. Rembrandt has to have been in his paintings, but Pollock was talking about it in a physical way.'

Since 1964—when he was only four years out of the Slade—Setch has spent most of his time in Wales as the Senior Lecturer in Painting at Cardiff College of Art. Previously he had lived in Surrey. He found 'the landscape of Surrey beautiful. It was like an overgrown wild garden. That and figures within a landscape became my subject matter very early. I liked being in the open.' The countryside on its own was never enough; his interest has always been in the tension between man and his environment. His early heroes were painters of the highest psychological impact: Munch, Bacon, Sutherland, and Palmer. 'When I was sixteen there was a big show of Munch in the Tate and that was that—I was going to be a painter,' he relates. 'As an introverted child I naturally understood getting lost in paintings. Munch and Bacon came to represent that condition.'

Setch describes his paintings as 'battlefields, discoveries of myself. The most difficult thing is starting a painting. I might come to it with countless thoughts and intentions, but it is a dead moment. Once in the painting there is a journey that sees me through.' Though his paintings are full of diverse images, there have been very few different themes. Recently he broke off from the Penarth beach paintings, which have dominated his life, to work on the Greenham Common women and then the Rehearsal series (Plate 54), which were inspired by visiting his daughter in rehearsal for a play. The latter paintings were uncharacteristically decorative, particularly after the seriousness of his previous subjects, but they underlined his links with painters like Rembrandt, Watteau, Auerbach, and Kossoff who conjure figures out of a landscape. He remembers the last two from his first year at the Slade. 'One heard about these two scrubbing away with charcoal making very black, heavy drawings.'

As the head of Cardiff's art school, Setch has never been far removed from events and painters in London and the international art world. He was one of the few British painters to be on the borders of New Wave. He showed at the old Museum of Modern Art in Paris alongside Julian Schnabel. 'Schnabel interests me a lot,' he says, 'he has a great deal of showmanship. He will make images that are uncomfortable and difficult to locate,' which is of course exactly what Setch does. American and European influences clash, but in his work they are tamed and brought in line with other School of London work.

Though Setch's massive *Touch the Earth Again* (Plate 55) was exhibited alongside an equally over-blown Kitaj in the 1987 *Art History* Hayward show—Catherine Lampert's endeavour to find contemporary British public art to rival Diego Rivera's murals —most visitors would not have seen many comparisons between the two paintings. Yet *Touch the Earth Again* has many similarities to other work by the first generation School of London painters. There is a new scale and a strong sense of performance, but the emphasis is still on the surface—its waxes, pigment and debris. The painting gives up its images grudgingly like a faded cave painting. The world he presents has turned full circle. It is primitive. It is not merely a warning of what might happen. It is not concerned with offering us a bright alternative future. There is no prospect of progress. It simply gives us glimpses of life where we least expect them.

Ken Kiff (born Essex 1935) was not in the *Human Clay* exhibition, but he could well have been as he uses paint like clay. Until recently Kiff and Paula Rego have been seen as isolated eccentrics. As late as 1980 John Hoyland, one of Britain's best known abstract painters, was using Kiff as a warning to younger artists. 'If you turn your back

on all that understanding of what's gone on in modern art,' he said, 'you're going to end up doing some idiosyncratic little kind of painting that doesn't belong to anything, like an escape . . . like Ken Kiff or somebody painting your own nightmares.' It sounds like sour grapes today, because Kiff and his working methods are now at the centre of attention.

The dispersal of images and the production of images out of the paint meet in Kiff's work. Criticism has concentrated on the artist's symbolism and psycho-therapy and this has yielded intriguing interpretations of his vivid, dream-like paintings, but has distracted attention from the way he makes the paintings. He puts contrasting images side by side like Kitaj, but there is a fluidity in his paintings which comes from a thorough understanding of his medium (Plates 56 and 57).

Kiff usually applies his paint thinly. 'If you use paint continuously thickly,' he writes, 'many kinds of softness and radiance and movements of the hand—and therefore of the mind—are just not technically possible. The use of space is also likely to suffer.' He is not concerned with producing images out of the paint, but does want the images to come out of the whole process of painting. This might at first sight seem a direct challenge to Auerbach's method. Indeed he has looked more to the 'Mozart-like grids by Klee', Braque and Miró rather than Soutine or Bomberg, but he does share ambitions for painting with painters like Auerbach and Kossoff. Both have dramatically reduced the amount of paint on the canvas in the last twenty years. It is the production of images out of the whole process of painting that is important, not just the physical paint. They and Freud reiterate time and time again that the medium is not the most important factor.

Kiff recalls that he has always had a sympathy with sculpture. 'I did masses of

56 Ken Kiff. *Black Cloud over Sea*. 1987–8. Watercolour. 22 × 29½ in (55.8 × 75 cm). Private Collection

plasticine modelling when I was a kid. It has always been a question of whether I should do sculpture as well. You have got this lump of clay or plasticine, only it isn't clay or plasticine, it's painting stuffs and consequently light, shadow, masses, and spaces. All the time you are moving this stuff about, you are pulling it into a space or pushing out a form. There is a trait running through artists who manipulate stuff. You can get that feeling of plastic intensity from Turner and it worked with Constable. He had a terrific feeling for the stuff of paint, but even so it puts you off.' The crucial 'stuff' to Kiff is the mental ingredients for his work and his success lies in the way he treats it as physical clay. He has welded the concept and process together in a similar fashion to the earthy fantasy of medieval sculptors, in particular Nottingham alabaster makers.

Head Incorporating a Blue Space, Face towards the Street (Plate 58) is perhaps the most dramatic result of pushing and pulling images with paint. Organs of the body have been clawed apart until they have a fifteenth-century Boschean life of their own. The force that tore limb from limb has formed a gap in the centre of the painting. This void is filled with a viscous blue until it too becomes a face in its own right. This is an 'organic' painting: one can almost feel it growing as the figures are stretched. Kiff suggests that distortion and fantasy are possibly related. 'Distortion combines meanings,' he writes, 'it shows, say, the human being, and it also shows qualities, say ecstasy.'

Kiff and Rego appear to be the antithesis of Francis Bacon, who has often said he hates stories, but they are far from being straightforward narrative painters. They have more in common with the way Bacon seized on the Greek tragedies to abstract the undiluted terror of the Furies and bleeding guilt of Orestes, than with early Renaissance pain-ters. Kiff does have very different views on myth and fantasy to Bacon. He thinks fantasy is a 'way of thinking about reality'. He is not afraid to illustrate. Through the monochrome drizzle of *Desolation: seq: no 101* (Plate 59) specific scenes can clearly be made out: a man hanging on a tree, a chariot driving away, and an enthroned classical figure thinking. They are all, however, tools to play the chords of one emotion. Like Walker playing his painterly scales in public, Kiff beats out a sequence of emotions.

Paula Rego (born Lisbon 1935) provided one of the shocks of the decade when she transformed virtually overnight from a spirit of wholesale exuberance to a stilled grandeur. I was taken aback on a visit to her studio in 1986. There was no excuse for surprise. She had already warned me of the change. Her work had been developing at a ferocious pace throughout the eighties. Indeed it had swung through one complete circle, from the early simple *gravitas* of *Monkey Drawing* and mindless rape of *Monkey and Chicken* through the gradual build-up to the most complicated profusion of stories in the *Operas, Drowning Bears* and *Vivian Girls* series. Every stage brought a new strength to her work till *Girl Playing with Gremlins* (Plate 62), *Paradise* and *The Bride* had forced a cohesiveness out of a mass of ingredients that kept the eye searching for hours. However, she had worked herself into an impasse.

The paintings of 1985 are Rego's most complete response to the need to pack the canvas with information. Their unity is totally dependent on the flow of her imagination and natural skill at composition. The reduction of the figures to cartoon level concentrates the attention on the actions. The emphasis is on speed and movement. There is so much going on that the eye is forced to jump and jump again. In *Girl Playing with Gremlins* a girl injects herself,

57 Ken Kiff. *Large Bird*. 1987–8. Oil on board, 48 × 36 in (122 × 91.4). Private Collection

58 Ken Kiff. *Head Incorporating a Blue Space, Face towards the Street*. 1982–3. Oil on canvas. 51 × 38 in (129.5 × 96.5 cm). Private Collection

59 Ken Kiff. *Desolation: seq: no 101*. 1977. Acrylic on paper, 27 × 21½ in (68.5 × 55 cm). E. B. Jackson

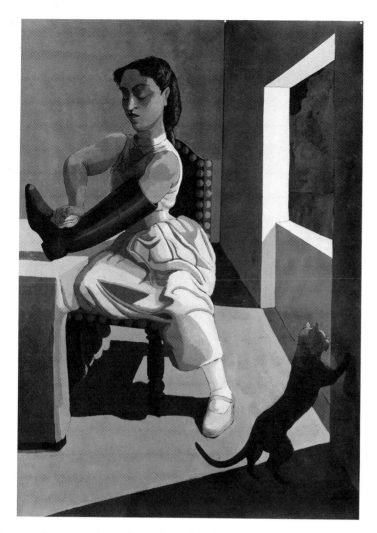

60 Paula Rego. *The Policeman's Daughter*. 1987. Acrylic on paper mounted on canvas, 84 × 60 in (213.4 × 152.4 cm). Saatchi Collection, London

Renaissance church and the mallet owe their existence to that one disturbed predatory look. Even more surprisingly *The Maids* (Plate 61) has the theatricality of Genet's maids after whom they are called. It appears to fall into that trap of which her husband, Victor Willing, warned. 'If there are figures there is an implication that somebody is doing something to somebody. Everything in the painting is part of the drama.' Rego seems to have relished this and at the same time inverted it. The drama is just one component. Her own liberal but comfortable background is contained in the painting. The maids are both Genet's symbol of liberalization from the bourgeoisie and Rego's Portuguese servants of old. There is her usual line of story-telling, but now that she has grounded the figures and set them in space, she has total control of priorities. The balance between the contemplative nature of the painting and the narrative is perfectly judged. As in the older pictures where the eye darted in and out looking for details, here the mind is bounced backwards and forwards between horror, suspense, and an inexplicable calm.

Rego's position in British painting was unclear. For many years she adapted the Cubist ethic in a highly original manner, but this was never a conscious decision. As her figures have grown in stature and into a more realistic space, links with mainstream British painters have emerged. She has infused a Freudian Surrealist dream element. Indeed she says that any connection with Cubism comes through Surrealism. She has confronted the tradition of British interior painting and now straddles the British/European tradition in a similar way to Balthus. She left the assimilation of many influences to this late date, so that there is no fear of it swamping one of the most individual visions of the second half of the twentieth century (Plate 60).

another takes delight in tearing the wings off an insect, one bird stands on its dignity and another smokes a cigar; it is a depiction of bedlam. She is an anarchist, not in a political sense, in that her sharp perception naturally topples people's neat emotional hierarchies. The bright colours, the whirlwind of activity and movement often give a misleading impression, disguising the sinister overtones that she was to make glaringly clear in subsequent paintings. Both the old and the new work rely on the same tension between good and evil. The latter has merely stopped skulking in the undergrowth.

Prey (Plate 63) revolves round one pair of shifting eyes. The billowing dress of the kneeling innocent, the crafty fox, the

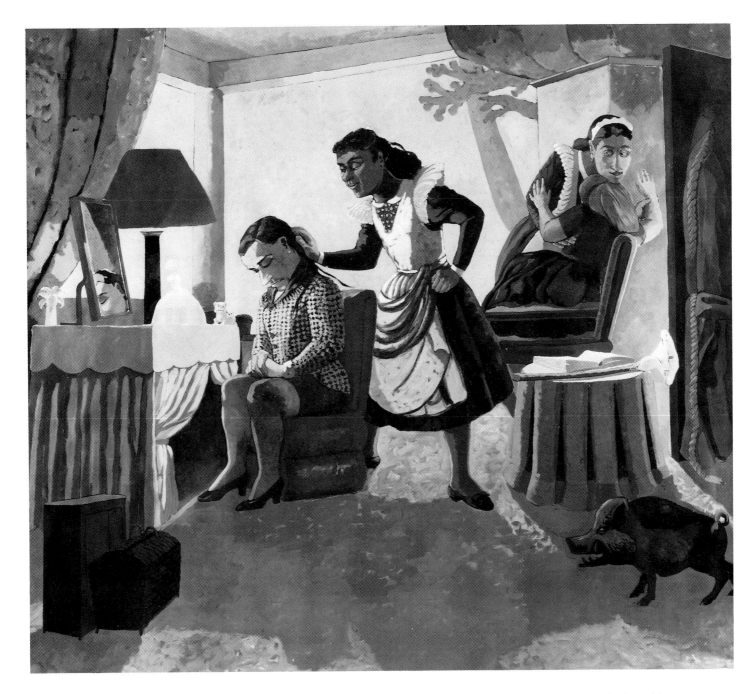

61 Paula Rego. *The Maids*. 1987. Acrylic on paper mounted on canvas, 84 × 96 in (213.4 × 243.9 cm). Saatchi Collection, London

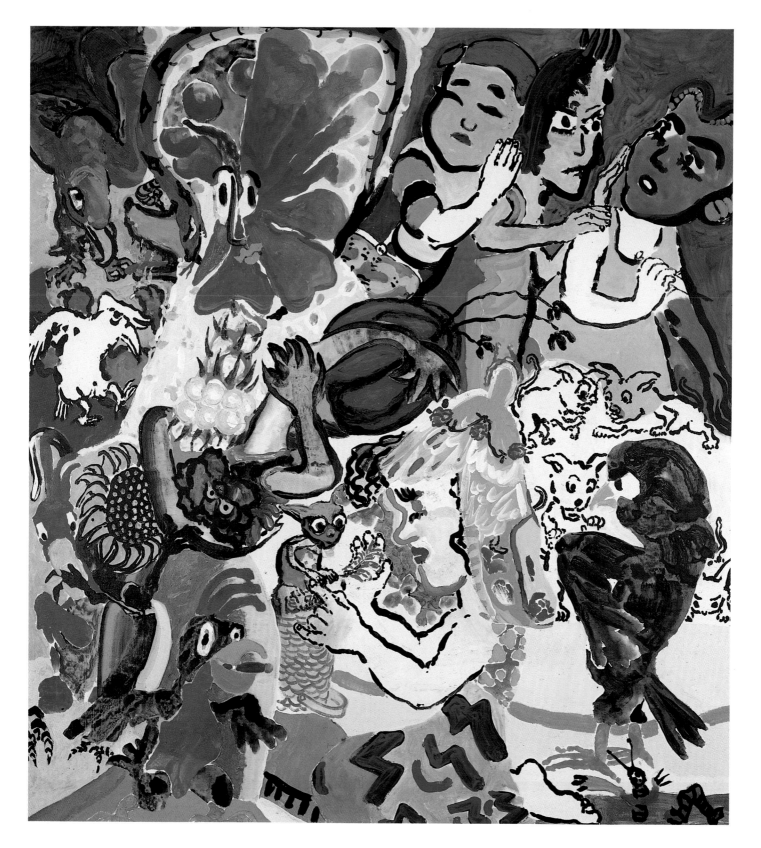

62 Paula Rego. *Girl Playing with Gremlins*. 1985. Acrylic on canvas, 86½ × 78¾ in (220 × 200 cm). Collection of the artist

63 Paula Rego. *Prey*. 1986. Acrylic on paper mounted on canvas. 59 × 59 in (150 × 150 cm). Richard Salmon, London

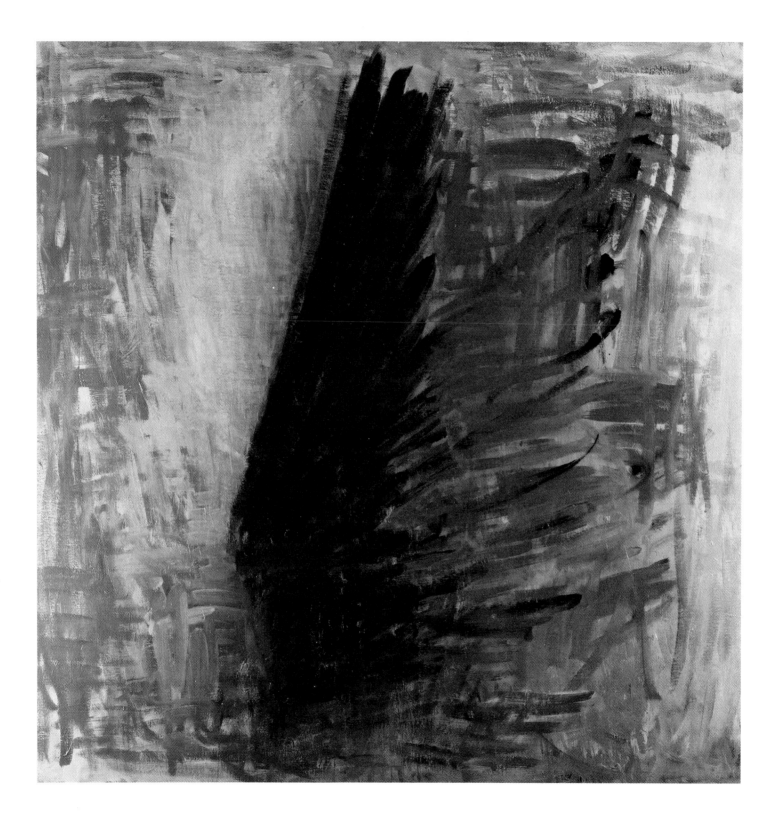

CHAPTER THREE
Sash of Paint

London's emerging young painters are as open to overseas influence as the artists of the first two chapters. The most famous have not been treated as particularly British phenomena. Le Brun has been involved in most of the major European exhibitions of the New Wave. Thérèse Oulton has lived and worked in New York and Vienna. Yet many of the strands of School of London painting come together most clearly in these and other artists. Hughie O'Donoghue at one time owed a vital debt to Bacon. Kitaj and Auerbach's influence intermingle in Arturo Di Stefano and Adam Lowe. Celia Paul cannot avoid being linked with Lucian Freud. Their striving for a new art is matched by their ability to imbibe and benefit from the old.

Christopher Le Brun (born Portsmouth 1951) is rarely accused of being volatile. He is usually associated with artists at least half a generation older than him. Tony Godfrey makes him the hero of his chapter, 'British Painting at the Crossroads' in *The New Image*, 1986. 'Probably,' Godfrey writes, 'the key pioneering figure in moving through abstract gestural painting towards a use of evocative and powerful imagery is Christopher Le Brun' (Plate 64). Jean-Christophe Ammann emphasises his painterly qualities. 'Christopher Le Brun is a wonderful example

of the truth that nothing can stand in the way of painting, whatever history may have in store for us.' However, there is an element of suspense. The mood is often subdued by a control of tone reminiscent of Whistler, but the viewer is left wondering. Where is he taking us? Where is painting going? Le Brun doesn't give answers, instead he assures us that he will continue to question the direction of painting.

With Bruce McLean, Le Brun has been the main British representative in European 'New painting'. From 'Zeitgeist' onwards he has been in most of the important group shows, yet he has the hallmark of a School of London painter. Images come out of the paint. He invokes reverie. His ambitious use of mythology struck a chord with the 'New Image' painting of Europe and America, but his exploitation of myth is almost incidental (Plate 67). It is not a device to hoist him into line with the masterpieces of antiquity. His is not a crude voice from the wilderness crying for the need of painting skills. Painting appears to come naturally to him, from the deep well of European and American tradition.

He trained first at the Slade and then at Chelsea. The painting *Landscape* started just after Le Brun had finished his post-graduate degree, demonstrates an almost casual ease

64 Christopher Le Brun. *Wing*. 1986. Oil on canvas, 84 × 83 in (213.5 × 211 cm). Private Collection

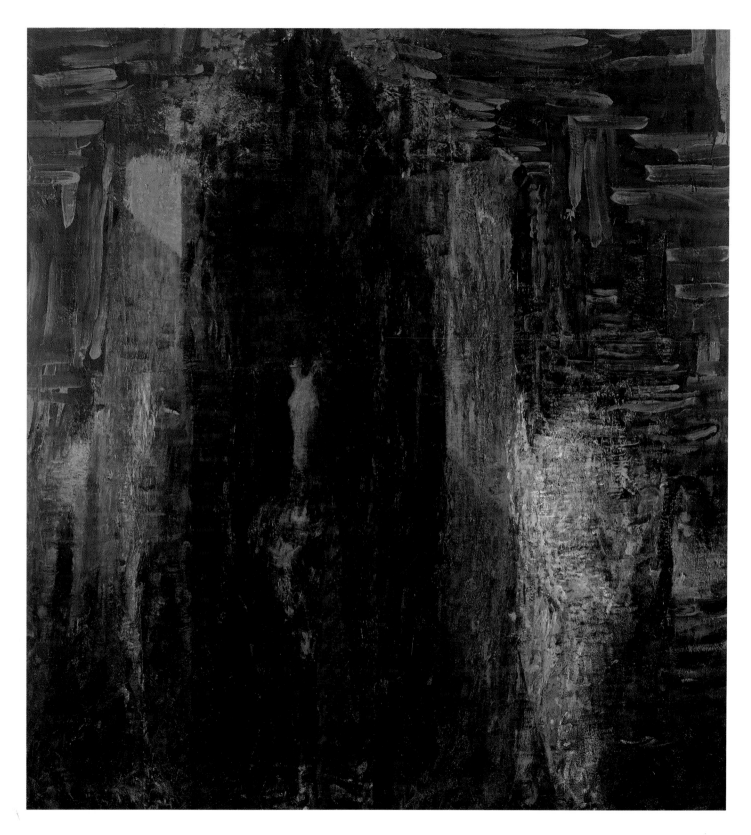

65 Christopher Le Brun. *Tower*. 1982–3. Oil on canvas, 95¾ × 89¾ in (243 × 228 cm). Private Collection, New York

66 Christopher Le Brun. *Cloud and Tree*. 1986. Oil on canvas. 72 × 60 in (183 × 152.4 cm). Frederick Roos

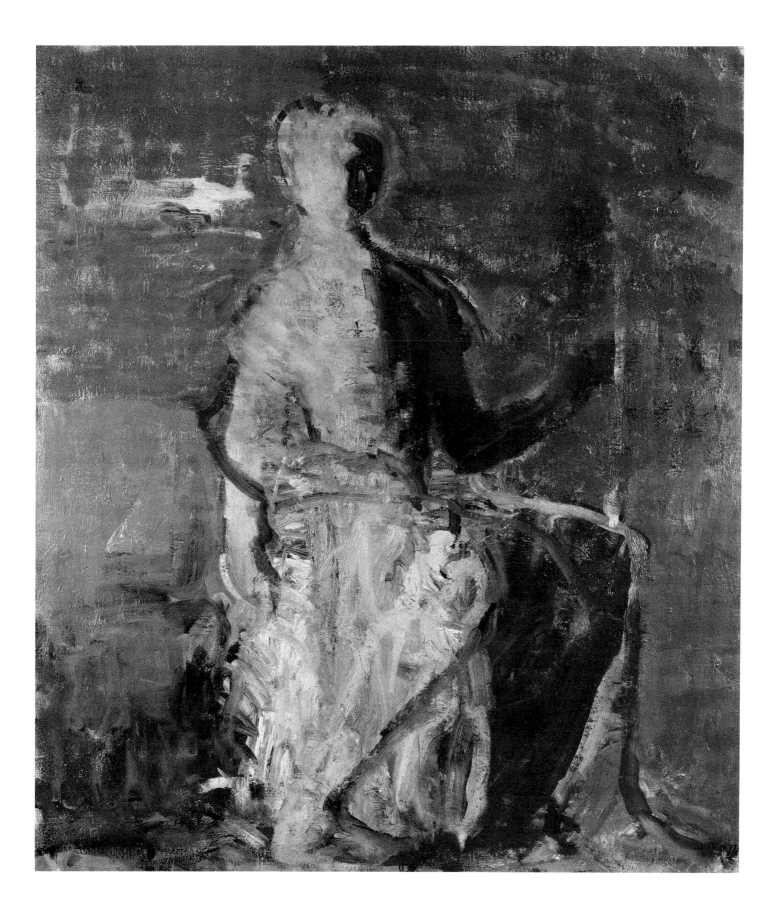

with a wide range of styles through Poussin, Claude, Richard Wilson, Cotman, and Gainsborough. His thematic treatment means he can be content with simple objects like horses, waves and trees (Plates 65 and 66). Yet he is certainly looking for more than mere mastery of technique. There is a restlessness in him, a constant striving for a content that will match the grandeur of his expectations for painting. There is a fuse in his work that hasn't yet exploded. It is more than ambiguity. For all its deceptive tranquillity his work is intriguingly unstable, his path forward unplanned.

The approval that greeted **Thérèse Oulton** (born Shrewsbury 1953) in the year or two after she left the Royal College at the age of thirty was startlingly wide ranged. Many praised her for qualities that she was trying to avoid. In marked contrast with Le Brun, she started life as a painter overladen with irony. With her rich paint, Wagnerian overtones, and apparent allegiance to the Romantic landscape tradition, she appealed to the Right. With her avowed feminism she was in natural sympathy with the Left. Ostensibly she had argued her paintings into an impossible position, but this was caused by other people's interpretations and not the work itself.

Oulton's work is a mass of contradictions. Once she had been hailed as the latest in the line of great Romantic landscape painters, she immediately reduced any features that could be interpreted as landscape. The *Dissonance Quartet* paintings of 1985–6 are the result (Plate 68). The colours, the scale and the sweeping areas of paint encourage the spectator to look into the painting as though it was a Turner, but once the eye is caught it finds itself on an ever diminishing spiral, for there is no definitive reading of these pictures. She holds out the promise of gold at the end of the rainbow, but it is the 'Fools' Gold' of the title of her first one-woman exhibition. She entices the viewer into endless cul-de-sacs, but there are surprises. Brought up close to the paintings to examine the enticingly rich surface, there is the discovery of bare patches. The paint is often thin. The close physical relationship of the painter with the paint is underlined by the realization that she uses her hands. She kneads the paint onto the canvas. She punctures the cosmetic surface to bring us back to her concerns, for though she has the tightest of intellectual control over composition, steering us to constant denials and refusals of traditions and conventions, the sheer power of her painting ability is never fully restrained. Head and heart are torn from each other (Plate 69).

Oulton left London as she felt, 'It was important to get some perspective on our world here, even if it diminishes it.' She is constantly looking for ways to diminish her past ties. Two artists loom in her background, Titian and Pollock, but both have come to epitomize male artistic conceits. She far from denies their influence, but has tried to rationalize and reduce its impact, translate it into the very different way that she sees the world. 'Pollock has always been presented walking on a knife edge,' she says, 'taking on the sins of the world, suffering and dying for us all. That is a very male message.' Like Bacon, Oulton does not wish to be trapped and categorized by words. She has built a pictorial language, which though it has a dramatic positive power of its own, is designed not to be translated into words. It appears negative when it is. However, Catherine Lampert in her introduction to *Fools' Gold* gives a fair summation of her dilemma and achievement. 'This tension,' she writes, 'suggests that Oulton's personal attraction to the bitterness of dichotomy is like her questioning of a masculine standard of successful painting. She seems to respect perseverance and prowess but be repelled by

67 Christopher Le Brun. *Virgil*. 1986. Oil on canvas, 70 × 62 in (178 × 157.5 cm). Private Collection

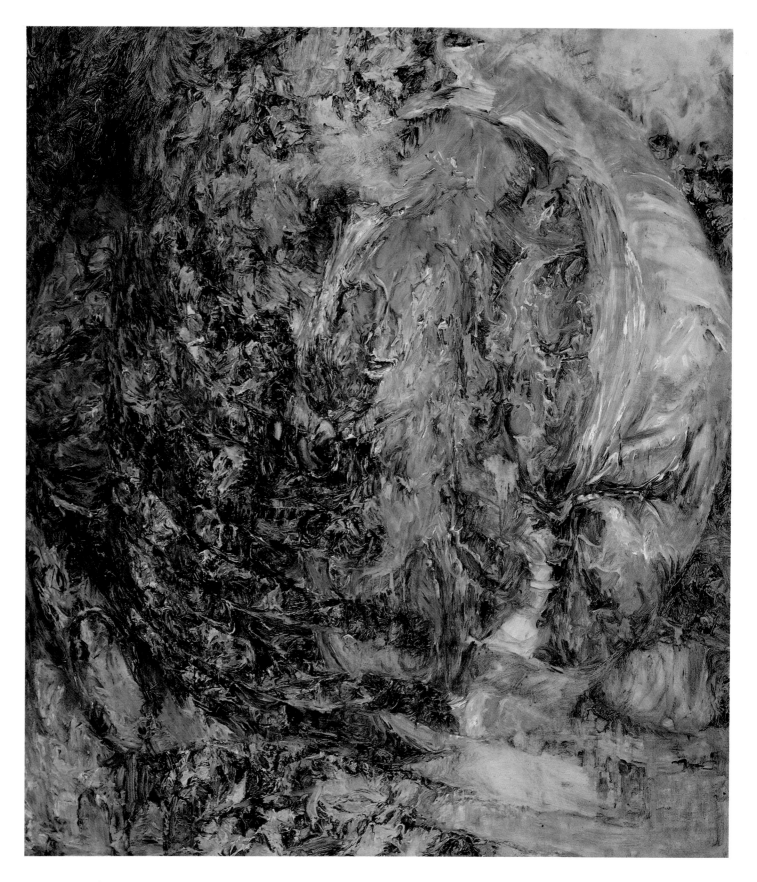

68 Thérèse Oulton. *Dissonance Quartet No 3*. 1986. Oil on canvas, 66 × 58 in (168 × 147 cm). Private Collection, USA

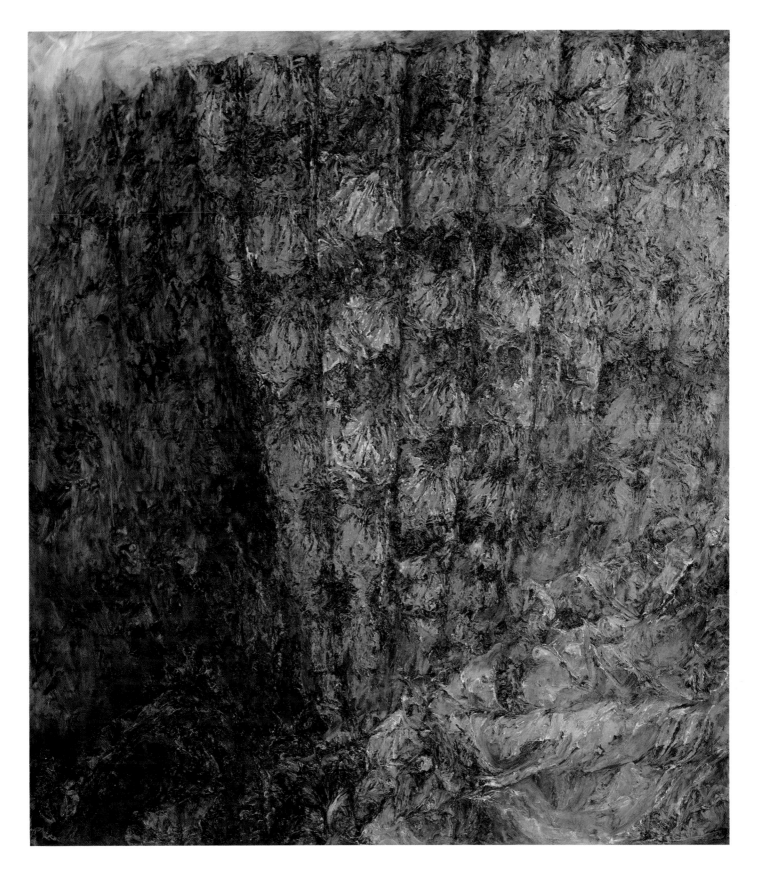

69 Thérèse Oulton. *List*. 1987. Oil on canvas. 94 × 84 in (238.8 × 213.4 cm). Marlborough Fine Art (London) Ltd

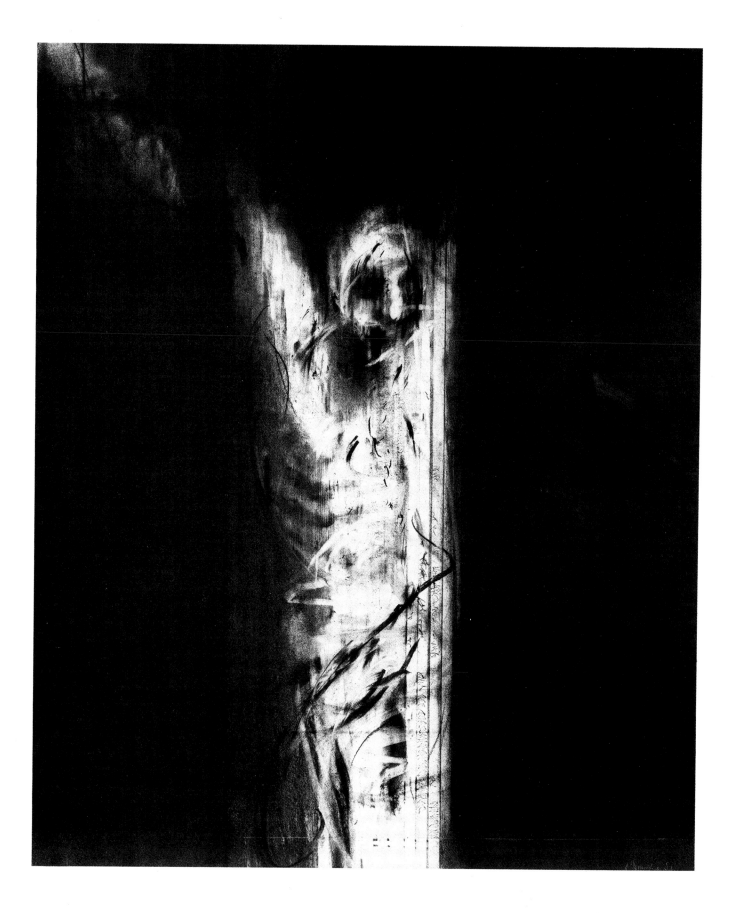

authoritarianism and analytic reductive-ness. Preserving intimacy and candour, female behaviour in its raw emotional state is a method of protecting the artist from painting with another person's values.'

The paintings of **Hughie O'Donoghue** (born Manchester 1953) have the strength of Revelation's trumpet blasts. They threaten a visual day of judgement. They force the viewer to look at them, to make his own mind up about painting. By the age of thirty, O'Donoghue's paintings were consistently giving 'a visual shock, to jolt the viewer out of complacency'. A year as Artist-in-Residence at the National Gallery helped him appreciate and welcome outside influence. He readily admits that some passages in his work 'were like making a nod to Bacon. I wanted to acknowledge his effect on me as a positive thing. It is not only the way he paints that I admire, but his attitude of constantly expanding his language.' He has the same grandeur of vision as Bacon. The main difference is one of conventions. Bacon traps emotion, O'Donoghue lets it wash off the canvas.

The four basic elements, Earth, Air, Fire and Water, and the interaction between them, are the main subject matter of O'Donoghue's paintings, just as they are vital ingredients of early mythology. The stuff of paint and his subject are therefore neatly interwoven. 'The subject,' he says, 'is a means of allowing one to make a picture.' It is certainly not important to understand the Laocoon myth to understand *Abyss* (Plate 71). Laocoon's punishment for offending Apollo and Poseidon, respectively Gods of the Sun and Water, gives the artist the perfect framework for his paint and emotions. Laocoon may be falling away into an everlasting abyss, being cast into oblivion, but the emphasis of the painting is still on the combustion of fire, on the dawn of a new world.

O'Donoghue is not a product of the art school system. Until 1979 he lived with his family in a remote part of Yorkshire isolated from the art world. However he was far from ignorant of what was happening elsewhere, making forays down to Cork Street and buying art magazines, many of which were unavailable in his home town. Though he 'found the kind of thing being done in Britain in the seventies completely unpalatable', he had a critical interest in the work of the American Minimalists and in particular Stella's black paintings. He saved his greatest praise for earlier Jasper Johns, 'those revelatory paintings of the fifties, very much of their time, yet rich with references and a quality that was timeless'. It was these painters and the Abstract Expressionists that led O'Donoghue to reject 'the idea of a picture being a window'. His developed style didn't materialize until he eased up on this restriction in the early eighties and allowed this convention to inch back into conflict with the idea of a painting as a two-dimensional object. This was re-inforced by his time at the National Gallery.

Every Friday at the National Gallery the Artist-in-Residence has to open his studio to the public and become the defender of contemporary art against all comers. 'The time I spent working there,' O'Donoghue recalls, 'was the most critical in my development as a painter. The access to the Collection was important and the constant questioning from staff and public alike required me to articulate my attitudes and position.' He became more positive to the traditions of painting and 'rejected the use of irony. I treated it as a commission to go into the National Gallery and make some response to the Collection. It was a relief to be able to freely relate my work to other work. It took away the idea that I was plagiarizing those other artists. Before I might have thought of making a study after El Greco but not

70 Hughie O'Donoghue. *Falling Figure*. 1987. Charcoal and conté on paper, 46½ × 39½ in (118 × 100 cm). Private Collection

105

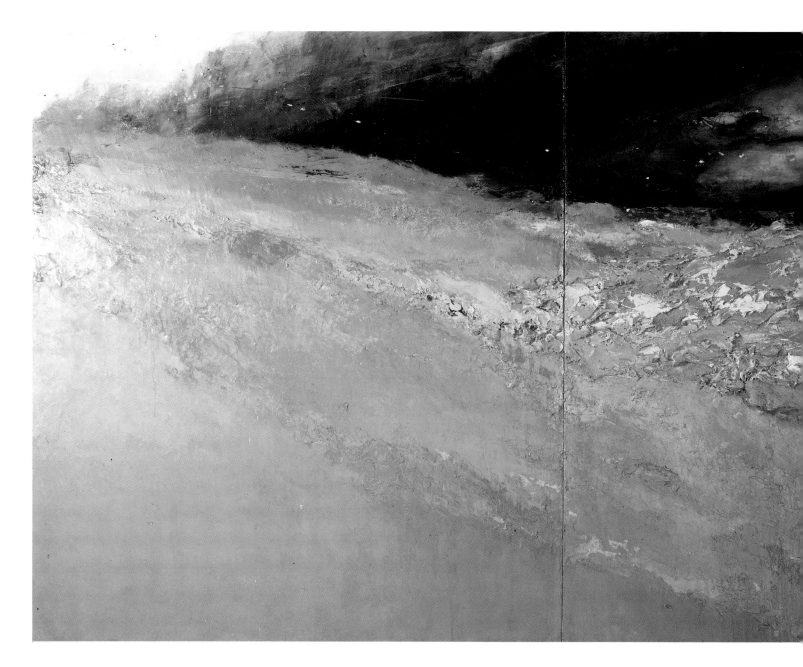

71 Hughie O'Donoghue.
Abyss. 1986–7. Oil on
canvas. 72 × 189 in
(183 × 480 cm).
Fabian Carlsson Gallery.
London

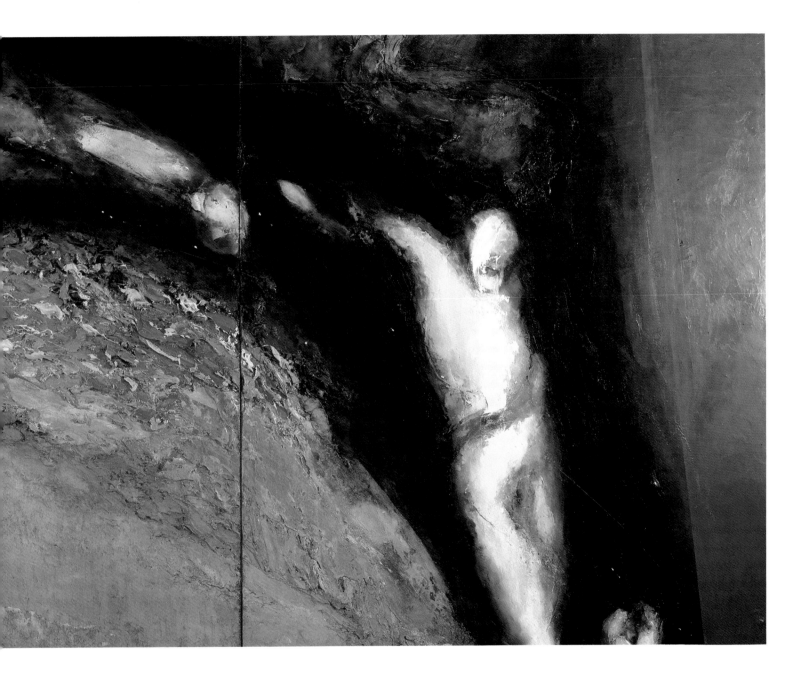

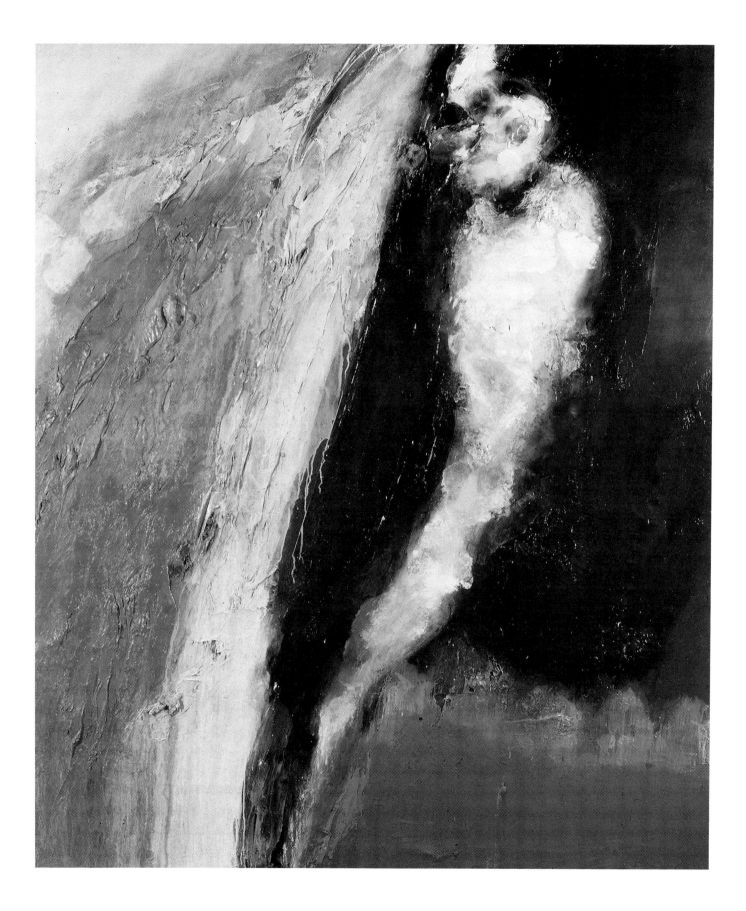

actually have got down to it.' El Greco, Titian, Rembrandt, Caravaggio, Cimabue . . . the rich list of influence is endless. The gallery staff also made him look at paintings in a new light. 'They would discuss pictures strictly in terms of how well they were painted. It was very refreshing.'

O'Donoghue's paintings work just as well viewed from two inches as from a distance. The surface is crucial. Layers of varnish support waves and mountains of impasto (Plate 72). The artist puts the viewer in two minds, whether to go forward to study the paint or be swept away by the scale of vision. His charcoal drawings also make the spectator peer in and out by creating a hovering illusion of figures and elements of landscape. His choice of subject, of dead bogmen from Denmark and crucified figures (Plate 70), has attracted the accusation of morbidity. Mel Gooding misleadingly writes that O'Donoghue's 'true subject is the dissolution of things'. The artist is analytical, he does use images and carbon materials that are the products of decomposition but only so he can demonstrate how the world is built up. He is positive. His art is wrapped up in the act of creation. It has the simplicity of Genesis.

Arturo Di Stefano (born Huddersfield 1955) has also been attacked for a preoccupation with death because of his series of paintings on dead writers, many of whom in their turn were obsessed by death. Di Stefano is the poet to O'Donoghue's novelist, and his most striking portrait heads are of poets: Baudelaire (Plate 76), Poe, Eliot and Auden. He is consumed by writers and writings, inheriting Kitaj's 'text-centredness' but reacting very differently. He has devised a technique that yields up literary figures in shrouded form, so that their image not only echoes but matches the way we read their work. 'At no time,' Di Stefano maintains, 'do these writers give you a world in which you can enter easily. You are not part of it. You can only engage in it if you realize it is something separate. It is a speculative world, in the sense that we look at it as if through a mirror.'

Di Stefano suspends belief, not so as to wallow in fantasy but so his reality viciously strikes the viewer. He quotes Eluard, 'There is another world and it is this one.' His writers may be dead, but he inhabits their world. He has a gallery of them in his head. Lines of poetry and prose clamour from them, but he does not let them spill out carelessly onto the canvas. His paintings are as concise as miniatures. Each evocation of a writer plays a different note, a note that encourages the mind to lead off into music. The technique purposefully induces ambiguity in the paint. The figures come out of the sweat and drips of paint (Plate 75).

Di Stefano's series of writers' heads, *Sudaria* (Plates 74 and 76), is called after the cloth St. Veronica used to wipe the face of Christ when he was carrying the Cross. His impression was 'miraculously' left upon it. Di Stefano's paintings are not rational portraits, but apparitions, figments of text. Indeed occasionally, as in *Sudarium: T. S. Eliot*, some lines have themselves tumbled from the image because they are so interwoven in his image of the poet. The artist is wreaking revenge on Mallarmé's declaration that 'the world exists, to end up in a book'. He is trapping the world and indeed these writers in his paintings. He capitalizes on the advantage of image over words.

Like Willing, Jackowski, and Le Brun, Di Stefano is a metaphysical painter intrigued by a scholarly reverie. This peace of mind was shattered by a fire in his studio in 1987. Ironically the event turned into a catalyst for a new series of paintings: *Palls*. He explains the impact of the fire by appealing to Eliot's concept of the 'objective correlative'. He is always looking for 'a set of objects, a situation, a change of events' to act as a

72 Hughie O'Donoghue. *Red Earth 11*. 1987. Oil on canvas, 60 × 52 in (152 × 132 cm). Fabian Carlsson Gallery, London

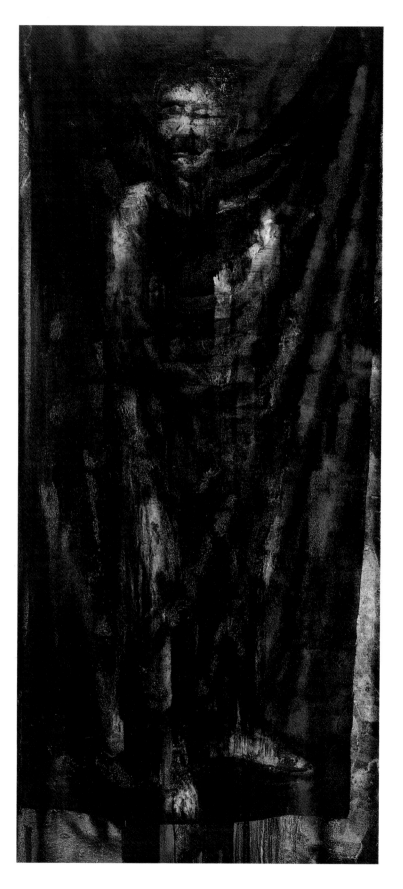

73 Arturo Di Stefano. *Pall: after John Donne*. 1987. Oil on linen.
84 × 38½ in (213.3 × 97.7 cm). Private Collection, London

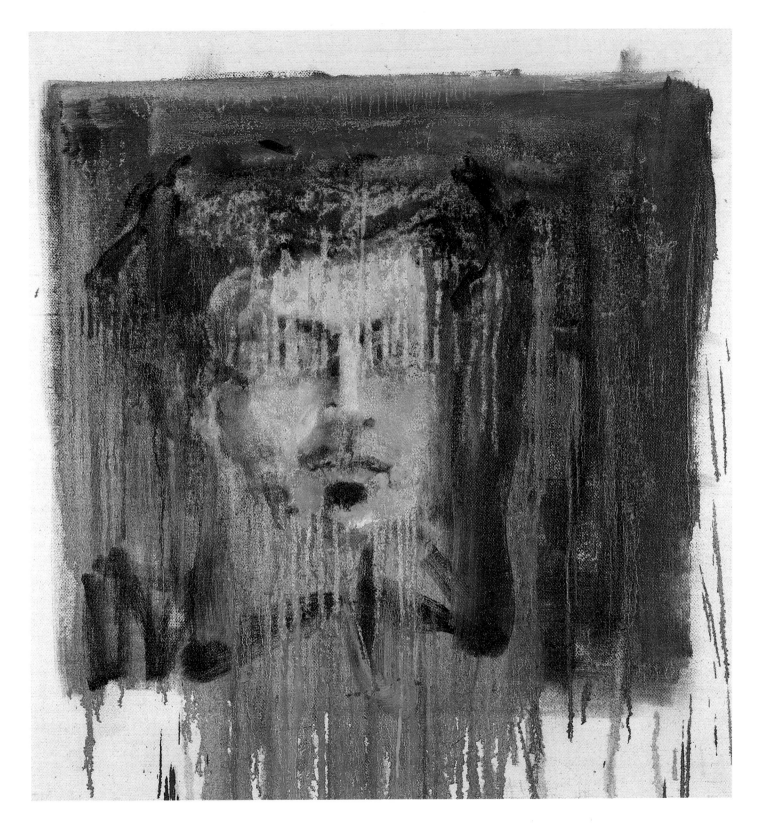

74 Arturo Di Stefano. *Sudarium: Antonio Gramsci.* 1986. Oil on jute, 38 × 36 in (96.5 × 91.4 cm). Private Collection, London

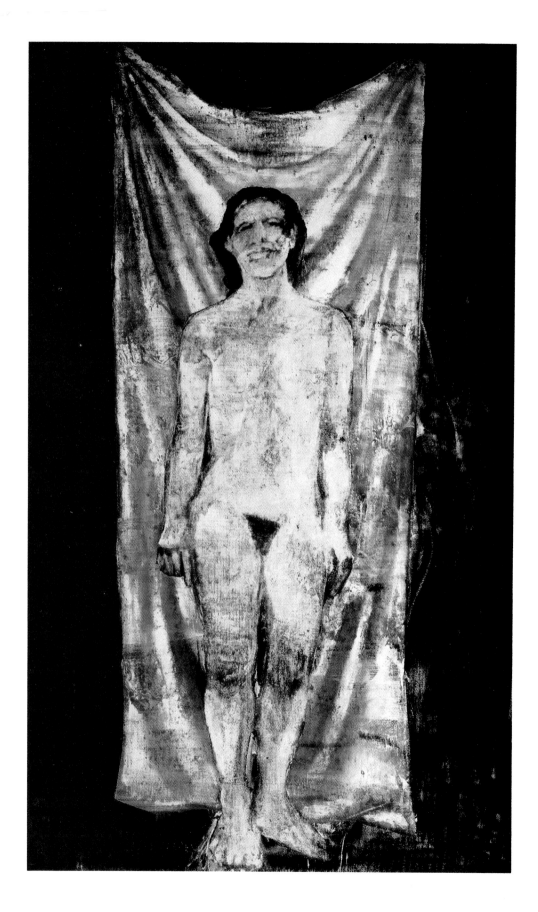

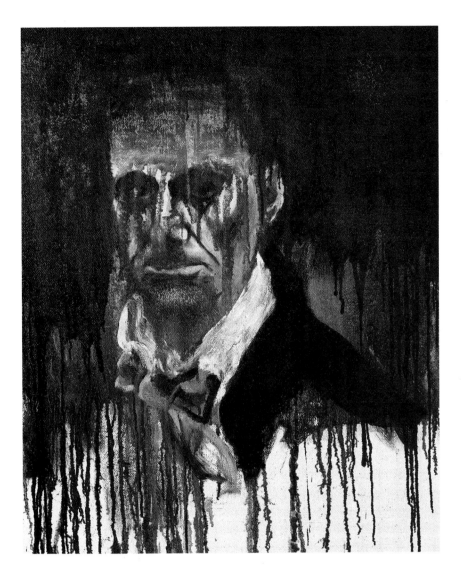

formula for an emotion.

Di Stefano's paintings can appear alarmingly straightforward. He made an abstract woodcut, which had the grain of the wood itself as the subject of the work. He called it *Woodsmoke* because the grain of the wood echoes the passage of smoke. The hanging cloths are both shrouds and smoke. In *Pall: after Donne* (Plate 73) the great metaphysical poet emerges from the burial sacking as solid as a pillar of stone and ethereal as fire. It is a simple image which nevertheless evokes debates. It can be interpreted like a Kitaj; one can read ideas out of it. Yet the

concentrated image can be appreciated like an Auerbach or Bacon. The subject of this picture is a metaphysical poet and it leads in as many directions as poetry itself.

Adam Lowe (born Oxford 1959) has experimented endlessly with different media to try and create a tension in the picture surface. He has mixed prints, wax, tiles, xeroxes, and oil in his attempt to, 'find a new approach to figurative work which will bring about a synthesis between the image, the drawing and the way it is made'. He pursues pure thought, but though his paintings are invariably contemplative they are always

76 Arturo Di Stefano. *Sudarium: Charles Baudelaire*. 1986. Oil on jute, 38 × 36 in (96.5 × 91.4 cm). Private Collection, London

75 Arturo Di Stefano. *Penelope. (Selvage)*. 1988. Oil on linen, 96 × 60 in (243.8 × 152 cm). Collection of the artist

113

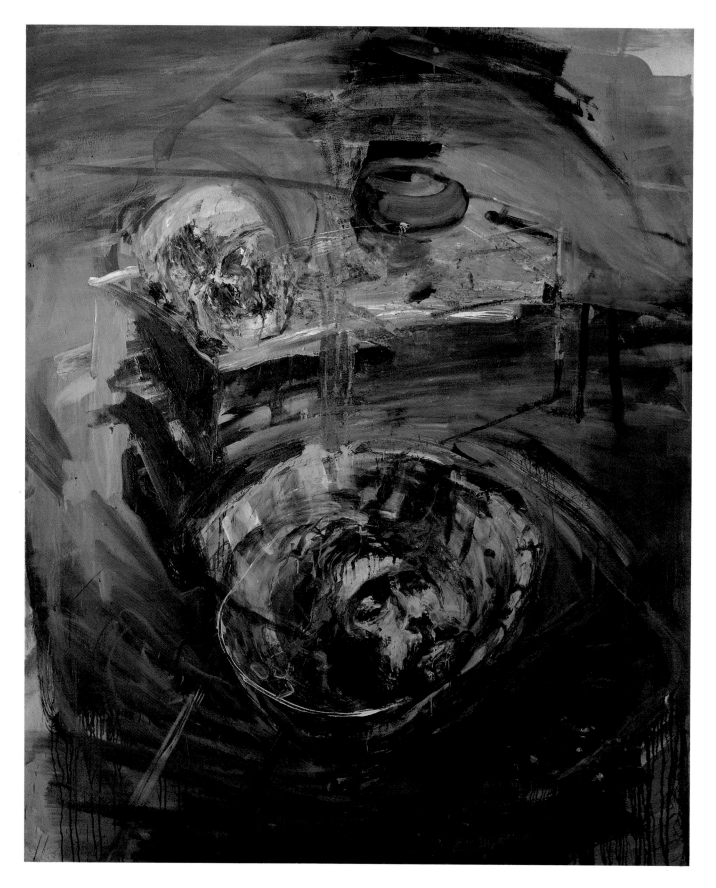

77 Adam Lowe. *Large Christdish*. 1986. Oil on canvas, 84 × 68 in (213.4 × 172.7 cm). Private Collection

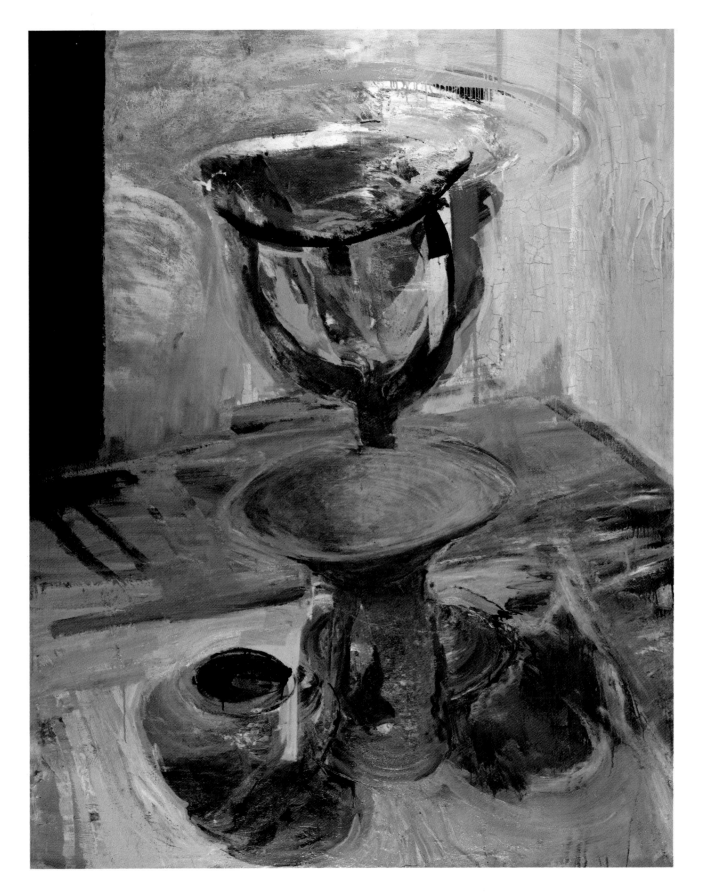

78 Adam Lowe. *Still Life*. July 1987. Oil and wax on canvas, 74 × 88 in (18 × 223 cm). Pomeroy Purdy Gallery, London

imbued with the physical energy of the artist, who has a streak of Hamlet's character. Since leaving the Royal College he has been at the centre of activity. He was instrumental in the setting up of the Richard Pomeroy Gallery in London with its associated studios, which was a serious attempt to create a meeting place for young artists.

In 1985 and 1986 a straightforward *Vanitas* approach led to the more complicated *Christdish* series. With the crown of thorns on the severed head, Lowe makes it clear that it is Christ in a dish and not John the Baptist. With the titles, *Christdish — Augustine* and *Christdish — Pelagius* he clarifies his reference to an early Christian debate over free will. The two fourth- to fifth-century theologians differed on the interpretation of Christ's death. For Augustine sin was unavoidable, for Pelagius it wasn't. Lowe is not a religious painter nor does he expect his viewer to be religious. He uses this debate, whose ramifications were to affect all subsequent Christian discussion of man's role, to seize the attention of modern minds and lead them down uncluttered channels.

Lowe could be accused of exploiting his public's ignorance. The imagery of *Large Christdish* (Plate 77) is sufficiently vivid on its own merits to act as a *Vanitas*, but once the viewer stumbles on the theological significance, he is pushed along unused philosophical paths. It probably would not have the required effect on a scholar of fifth-century theology, but then theologians are not buying as many paintings as they used to. Like Di Stefano and O'Donoghue, Lowe is treating Christian dogma in the same way as the older generations have plundered myths. As first Classical mythology and then Christian thought pass out of everyday coinage, these ideas have moved back into the depths of our consciousness and so become the perfect subject for artists.

Nevertheless the artist did feel restricted by the Christian debate within the *Christdish* series and has recently tried 'embedding these ideas in the *Still Life* paintings'. In his massive *Still Life* (Plate 78) he has reduced his subject to a series of pots, which he considers to be 'archetypal' shapes. Without the obvious distraction of ideas, the composition and paint grow in importance. He writes of his admiration for the 'heavy spaces of late Braque', whereas at one time he was looking to 'the naturalistic flourish of Rubens.' As Braque was in his later work, Lowe is looking to resolve the division between abstract ideas and the everyday world. His pots encourage pure undistracted thought, yet are also plain, down-to-earth objects.

Looming industrial machinery was the early hallmark of the paintings of **William MacIlraith** (born London 1961). He has continued to live on the south bank of the Thames since leaving Camberwell School of Art. *Inheritance* (Plate 81) clearly states man's anxiety about the world he is building, but like Cockrill, Setch, and Mason there is a strong primitive accent. The machine is dressed in a lizard skin which threatens to come alive and dominate the landscape like a fated dinosaur. A Fellowship to Syracuse University in New York State from 1986 to 1988 may have led to a greater abstraction, but ironically his absence from Britain has also heightened his links with other young British painters. As the remnants of machinery have faded into the background he pays homage to Titian's *Flaying of Marsyas* (Plate 42) in the metaphor of paint as broken skin. Both in his use of paint and distant references to mythology he has declared his 'allegiance and sympathy to the poetic nature of things physical and collective experience'. He points to the Orpheus and Eurydice myth to explain his process of painting, quoting Maurice Blanchot.

79 William MacIlraith. *Journey.* 1980. Raw pigment and charcoal on paper, 56¾ × 60½ in (143.2 × 153.7 cm). Private Collection

80 William MacIlraith. *Veil*. 1987. Charcoal, wash and raw pigment, 14⅜ × 13¼ in (36.5 × 33.7 cm). Private Collection

81 William MacIlraith. *Inheritance*. 1986. Oil and wax on canvas, 82¾ × 65¾ in (210.2 × 167 cm). Private Collection

'Orpheus descends to Eurydice . . . Eurydice is the limit of what art can attain . . . Concealed, covered by a veil . . . She is the point of profound darkness. His work is to bring it back into the daylight and give it form.' Young painters have looked to the myths with the earliest roots to underline the need to reappraise the whole of art history and not just react to the art of the immediate past. Once more we are looking for ways to explain how we live through an imaginary evolution (Plates 79 and 80).

The first glance at *Family Group* (Plate 83) by **Celia Paul** (born India 1959) might make an outsider think that British painting had stopped still. Comparisons with Freud's *Large Interior, W11 (after Watteau)* (Plate 27) are unavoidable. The inheritance from the first generation of School of London is unmistakable. She has the harsh gaze of Freud, makes paint into flesh, and has the same work ethic as Freud and Auerbach. 'I am very uncomfortable when I am not working,' she says. She has a similar temperament to Auerbach. At the Slade she never made a painting, only drawings. Auerbach was just as slow. 'At art school,' he remembers, 'when we had a life model, say for four weeks, I never finished a painting. It took months and years to finish a painting.' She shares Bacon's distrust of expressionism though her response to this is very different. 'Drawing,' she writes, 'is very important to me because it is the control that stops a painting turning into expressionism.'

Paul is far from being derivative. She has brought an intimacy of her own to painting. 'My work is about people and their emotions,' she says. It is her only subject matter. 'I have never painted a landscape,' she continues, 'because we have never lived anywhere that has given me that emotional pull. I can't feel as urgent about things that are not human.' She paints her immediate family again and again, her mother (Plate 82), sisters and their children. The technique is ruthless, but catches the subtlest of moods. *Family Group* portrays her family after the death of her father. Her solid and monumental sitters are in a silent world. They are suspended in a private, fragile vacuum and yet its creation has most definitely been touched by the outside world. The artist admires other creators of intimate worlds like Charlotte Brontë, George Eliot, and Nabokov. Frans Hals and Rembrandt are her guides amongst the masters.

Unlike the first generation of School of London, Celia Paul has been able to borrow some of the grammar for her new language from other living British painters. The School of London is not an international art movement, it is a stream of painting. Today, for the first time for many years there is a current of thoughts and styles capable of feeding the first stages to great art.

82 Celia Paul. *My Mother Looking in the Mirror*. 1984. Charcoal on paper, 27 × 21½ in (68.5 × 54.6 cm). Saatchi Collection, London

83 Celia Paul. *Family Group*. 1984–6. Oil on canvas, 65 × 78¾ in (165.1 × 200 cm). Saatchi Collection, London

84 Lucian Freud and Francis Bacon in Bacon's studio, 1953

85 Frank Auerbach in his studio, 1970

SELECT BIBLIOGRAPHY

Dawn Ades, Andrew Forge, *Francis Bacon* (exhibition catalogue), Tate Gallery, London, 1985

Doré Ashton, *John Walker, Paintings from the Alba and Oceania Series 1979–84* (exhibition catalogue), Hayward Gallery, 1985

Doré Ashton, *Robert Mason* (exhibition catalogue), Yale Center for British Art, New Haven, 1986

Art of our Time, The Saatchi Collection (exhibition catalogue), The Royal Scottish Academy, Edinburgh, 1987

Stephen Bann, *Christopher Le Brun, Paintings 1984–85* (exhibition catalogue), The Fruitmarket Gallery, Edinburgh, 1985

Andrew Brighton, 'Arturo Di Stefano', *Art Monthly*, December 1987

British Art in the 20th Century: The Modern Movement (exhibition catalogue), Royal Academy of Arts, London, 1987

Bruce Chatwin, *Howard Hodgkin, Indian Leaves* (exhibition catalogue), Petersburg Press, London 1982

Lynne Cooke, John McEwen, Victor Willing, *Victor Willing, A Retrospective Exhibition 1952–85* (exhibition catalogue), Whitechapel Art Gallery, London, 1986

Current Affairs: British Painting and Sculpture in the 1980s (exhibition catalogue), British Council, Museum of Modern Art, Oxford, 1987

Peter Fuller, 'Michael Andrews, Recent Paintings', *The Burlington Magazine*, July 1986

Peter Gidal, Catherine Lampert, *Thérèse Oulton, Fool's Gold* (exhibition catalogue), Gimpel Fils, London, 1984

Tony Godfrey, *The New Image: Painting in the 1980s*, Phaidon, Oxford, 1986

Mel Gooding, 'Hughie O'Donoghue at Chapter', *Artscribe*, September–October 1986

Lawrence Gowing, *Michael Andrews* (exhibition catalogue), Hayward Gallery, London, 1980

Lawrence Gowing, *Lucian Freud*, Thames and Hudson, London, 1982; paperback 1984

Lawrence Gowing, *Leon Kossoff* (exhibition catalogue), Anthony d'Offay Gallery, 1988

Lawrence Gowing, *Howard Hodgkin* (exhibition catalogue), M. Knoedler, New York, 1981

Germaine Greer, 'Paula Rego', *Modern Painters*, Volume 1 Number 3 Autumn 1988

The Hard-Won Image: Traditional Method and Subject in Recent British Art (exhibition catalogue), Tate Gallery, London, 1984

Keith Hartley, Alexander Moffat, Alan Bold, *John Bellany* (exhibition catalogue), Scottish National Gallery of Modern Art, Edinburgh, 1986–7

Tim Hilton, *Gillian Ayres* (exhibition catalogue), Serpentine Gallery, London, 1983

Robert Hughes, *Lucian Freud, Paintings* (exhibition catalogue), Hayward Gallery, London, 1987–8

Human Clay, An Exhibition Selected by R. B. Kitaj (exhibition catalogue), Arts Council, Hayward Gallery, London, 1976

Timothy Hyman, Martha Kapos, *Ken Kiff, Painting 1965–85* (exhibition catalogue), Serpentine Gallery, London, 1986

R. B. Kitaj, 'The Autumn of Central Paris (After Walter Benjamin) 1971', *Art International*, March 1979

Leon Kossoff, Catherine Lampert, *Frank Auerbach, Retrospective Exhibition* (exhibition catalogue), Hayward Gallery, London, 1978

Catherine Lampert, *Frank Auerbach, Recent Paintings and Drawings* (exhibition catalogue), British Pavilion, XLII Venice Biennale, 1986

Helen Lessore, *A Partial Testament, Essays on Some Moderns in the Great Tradition*, Tate Gallery Publications, London, 1986

Marco Livingstone, *R. B. Kitaj*, Phaidon, Oxford, 1985

Norbert Lynton, *Andrzej Jackowski* (exhibition catalogue), Marlborough Fine Art, London, 1986

Stuart Morgan, 'Interview with Christopher Le Brun', *Artforum*, December 1982

Richard Morphet, *Howard Hodgkin, Forty Five Paintings: 1949–75* (exhibition catalogue), Serpentine Gallery, London, 1978

A New Spirit in Painting (exhibition catalogue), Royal Academy of Arts, London, 1981

Michael Peppiatt, Jean Clair, Timothy Hyman, Avigdor Arikha, Thomas West, 'The School of London', *Art International*, Autumn 1987

John Russell, *Francis Bacon*, Thames and Hudson, London, 1971; revised edition (World of Art), 1979

A School of London: Six Figurative Painters (exhibition catalogue), British Council, Kunstnernes Hus, Oslo, 1987–8

Terry Setch, 'An Alternative View', *Art Monthly*, June 1982

Frances Spalding, *British Art since 1900*, Thames and Hudson, London, 1986

David Sylvester, *Interviews with Francis Bacon*, Thames and Hudson, London, 1975; revised and enlarged editions 1980 and 1987 as *The Brutality of Fact: Interviews with Francis Bacon*

INDEX